The Night Watch

GARY SCHWARTZ

Lights! Paintbrush! Action!

THAT IS THE KIND of thrill people feel in front of Rembrandt's painting in the Rijksmuseum (fig. 1). Something grand and exciting is about to happen, and we are witnessing it. It is not so much an occurrence from real life as a staged happening, but none the less rousing for that. The painting has an historical name that captures its spirit. 'The young lord of Purmerland, as captain, orders his lieutenant, the lord of Vlaardingen, to march out his company of civic guardsmen' (fig. 2). A captain gives a command and a company of armed men comes alive. This is a scene of authority and obedience, of power and spectacle. Yet, although a hierarchy binds the company, the men do not behave like soldiers obeying a command. Everyone in the scene has a character and direction of his own; they look as if each has a mind of his own. They are marching out because they want to and because they enjoy it. The mood is infectious.

What kind of painting is this? Who are the people in it and what exactly are they doing? Whose idea was it and who paid for it? How did Rembrandt come to make it? What sources did he use and what ideas did he have? Why is it on display in the Rijksmuseum? How did it get its name? What have people thought about it down through time? These are some of the questions that will be answered in this book. At the end we will answer a question that is too often left out of books on art: What is the condition of the painting after all these centuries and after it was attacked with a knife? Is it still the painting Rembrandt left us? (The short answer, for those need to know it now, is: Basically, with a number of important qualifications, yes.)

1

1

Rembrandt, *Officers and guardsmen of the Amsterdam musketeers' company of Captain Frans Banning Cocq, called the Night Watch.* Amsterdam, Rijksmuseum. Begun in 1639 or 1640, completed in 1642, when it was signed and dated. The medallion, which was not painted by Rembrandt, lists the eighteen officers and guardsmen in the painting:

Frans Banning Cocq

heer van Purmerlant en Ilpendam

[lord of Purmerland and Ilpendam]

Capiteijn [Captain]

Willem van Ruijtenburch van Vlaerding

heer van Vlaerdingen' leutenant

[lord of Vlaardingen, lieutenant]

Jan Visscher Cornelisen' vaendrich,

[standard-bearer]

Rombout Kemp' Sergeant

Reijnier Engelen' Sergeant

Barent Harmansen

Jan Adriaensen Keyser

Elbert Willemsen

Jan Clasen Leijdeckers

Ian Ockersen

Jan Pietersen Bronchorst

Harman Iacobsen Wormskerck

Jacob Dircksen de Roy

Jan vander Heede

Walich Schellingwou

Jan Brugman

Claes van Cruysbergen

Paulus Schoonhoven

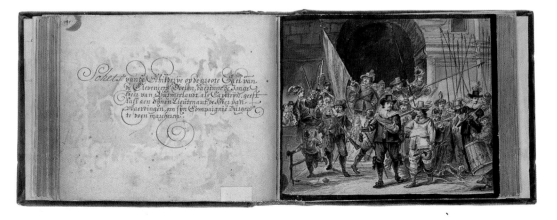

2

Jacob Colijns(?), *Drawing of the Night Watch in the Banning Cocq family album.* Amsterdam, Rijksmuseum. This drawing of the Night Watch, made for Captain Banning Cocq, does not mention that it was painted by Rembrandt.

Group portraits of Amsterdam guardsmen

The *Night Watch* is a painting of a very specific kind. It is a group portrait of a company of civic guardsmen - citizens who served part-time in a military body. Paintings of this kind were not made everywhere. Nearly all the surviving examples come from the Low Countries; within the Low Countries from the county of Holland; and in Holland most from Amsterdam. A flourishing tradition of guardsmen's portraits tells us certain things about the society that produced them: the civic guard had a certain autonomy and an identity of which it was proud; people thought that group portraits flattered that identity; there were artists capable of painting such works so well that guardsmen wanted to commission them; there were buildings for them to hang. In order for these large and unwieldy paintings to survive the ages and to be respected by posterity, something else is required: a long period of social and political continuity.

Considering all these factors, it says a lot that the city of Amsterdam today owns no fewer than 57 group portraits of militiamen from the sixteenth and seventeenth centuries. The earliest dates from 1529, the last one from 1656. There have been several major upheavals in the Netherlands during and after that time: the eighty-year-long revolt against Spain (1579-1648); the dissolution of the Dutch Republic in 1795; French rule over the country (1795-1813); the German occupation in the Second World War (1940-1945). Moreover, the civic guard itself was often disbanded or transformed in the course of its existence. None of this however disturbed the pride of Amsterdamers in their forebears or prevented them from honouring them by

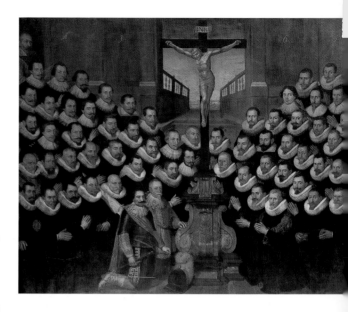

3
J. Bollen,
Officers and guardsmen of the musketeers' guild of the city of Mechelen in the southern Netherlands. Signed and dated 1630. Mechelen, City Museums. This contemporary painting of a similar group as in the *Night Watch* is about as different as a group portrait can be from Rembrandt's.

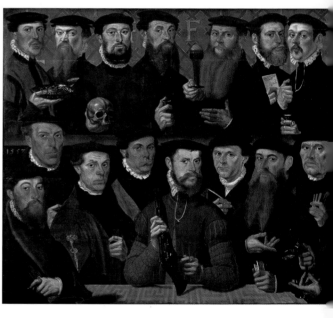

4
Anonymous,
Seventeen guardsmen of Platoon F of the Amsterdam musketeers' guild. Dated 1557. Amsterdam, Amsterdams Historisch Museum. The firearm held by the captain was new and costly for the time.

preserving and displaying their portraits as military men. Except for a few years during the Second World War, the *Night Watch* has always hung in a public building in Amsterdam. This speaks of an impressive continuity in Dutch culture, a continuity of which the *Night Watch* itself is one of the most famous symbols.

Although we call them by the same name, there are significant differences among various kinds of civic guard portraits. The can be pious, solemn, ceremonial, heroic c convivial. When the musketeers of Mechelen had themselves painted in 1630, they thought it fitting to be shown on their knees, row on geometrical row, praying to

e crucified Christ while looking directly
the viewer (fig. 3). Their poses speak of
questioning faith, of a group more
nportant than the sum of its individual
embers, of ranks closed to outsiders, of
edience. The Dutch of the north prefer
express something else about them-
lves: concord, group bonding, allegiance
the city and the state, a bit of personal
nity, and a confidential relationship
th the viewer.

The Amsterdam civic group portraits
me from three buildings, each of which
longed to a different branch of the civic
ard with its own military function.
hese bodies were called guilds – *schutters-*
.den (guilds of marksmen) – like the pro-
fessional and trade groups in every Euro-
pean city. The division of the *schutters* was
originally based on the weapon that the
respective groups were trained to use: the
crossbow, the handbow and a firearm
known as a *klover*. This group, the one
that ordered the *Night Watch*, were called
the *Kloveniers*.

Each guild had its own headquarters
and practice range, called a *doelen*. The
crossbow- and handbowmen met on the
Singel Canal, in buildings that now house
the library of the University of Amsterdam.
From its founding in 1522, the Kloveniers
had at their disposal a tower a short way
from the other buildings, at the juncture
of the Amstel and a canal that soon came
to be named after them, the Kloveniers-
burgwal.

In their main themes, the Amsterdam
civic guard portraits break down into sev-
eral categories. The older ones tend to show
an arrangement of half-length portraits of
sitters against a flat background, with or
without attributes of their guild (fig. 4).
Others show them in a particular setting
or involved in an event of some kind. The
most usual occurrence is the annual ban-
quet, the communal highpoint of the year.
However, there are also civic guard por-
traits that show a company in action. On
one occasion, in 1623, the civic guard was
called to the field to stand in for a company
of regular troops in the States army. Some

5

Frans Badens (?), *Officers and guardsmen of the*
Amsterdam crossbowmen's company of Captain Arent
ten Grootenhuys, painted about 1613.
Amsterdam, Amsterdams Historisch Museum.

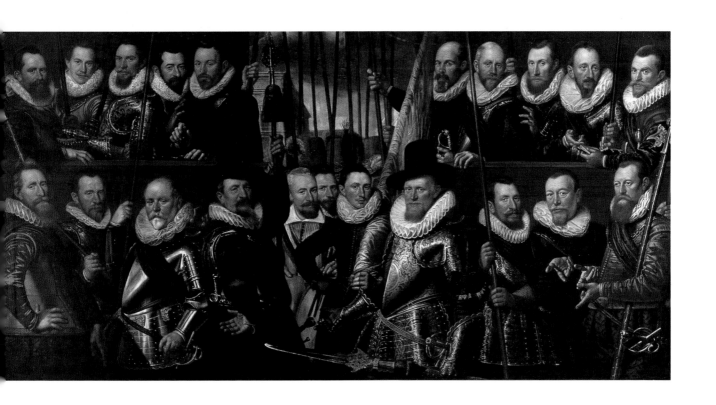

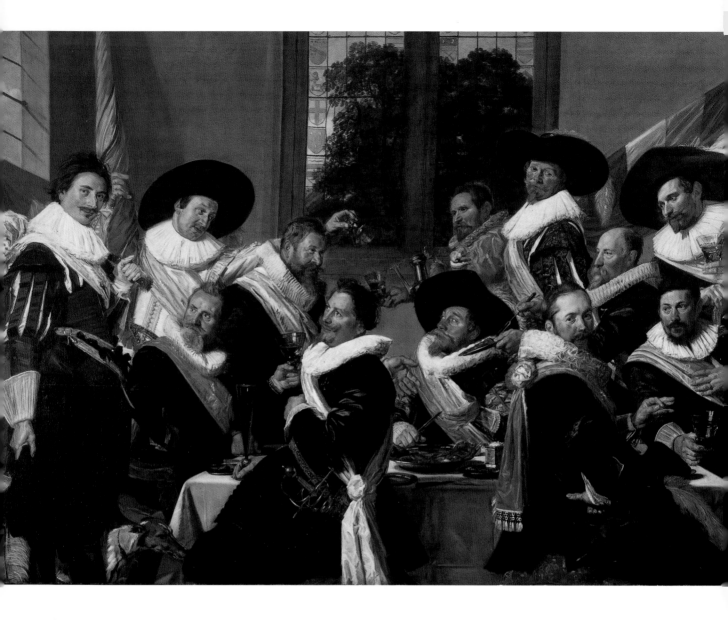

civic guard portraits have an outright military look, with the men in heavy armor, ready to go into combat (fig. 5), while others show them completely relaxed (fig. 6).

There is little reason to think that choices of this kind were left up to the painter. One would imagine that a company ordering a group portrait knew in what mode it wished to present itself. However, we have no certainty on this matter. The few documents referring to group portraits are about price and delivery, not poses and modes. Perhaps the best assumption is that the specificity of the artist's instructions varied from case to case. The guardsmen will have picked out a model from the existing gallery of examples, and the painter will have invented his own variant. The relative contribution of each party will have depended on various circumstances, of which not the least important will have been the creativity of the artist and his powers of persuasion.

6

Frans Hals, *Officers' banquet of the Haarlem musketeers' guild*. Painted in 1627. Signed FHF. Haarlem, Frans Hals Museum. Portrayed are all the officers who served in the years 1624-1627. Frans Hals was the only painter who was brought in from Haarlem to paint an Amsterdam civic guard portrait. This example is however from Haarlem.

The commission

The origins of the *Night Watch*, the space for which it was ordered and its place in the tradition of civic guard portraits can be fixed with some precision. The earliest mention of the painting is a fairly detailed and reliable document drawn up by a member of the Amsterdam town council named Gerrit Schaep Pietersz. In February 1653 he wrote a 'Record and list of the public paintings preserved in the 3 *doelens*, as I found them on my return to Amsterdam in February 1653' (fig. 7). In the Kloveniersdoelen he noted seven paintings in the large upstairs hall, of which one was 'Frans Banning Cocq, captain, and Willem van Ruytenburg, lieutenant, painted by Rem-

brandt in the year 1642.' This is unusually exact information to have concerning any old master painting, and it is confirmed by all other known facts. The most important of these is a drawing of the painting (or of a small copy of it; fig. 2) in the family album of the captain himself, also dating from the early 1650s. Among stories and genealogical information about the captain's ancestors, especially those on his mother's side, there is a calligraphic inscription opposite the drawing: 'Sketch of the painting in the great hall of the Kloveniersdoelen, in which the young lord of Purmerland, as captain, orders his lieutenant, the lord of Vlaardingen, to march out his company of civic guardsmen.' Even though the artist is not named, there can be no doubt that it was Rembrandt. Two more documents confirm this. In 1659, in connection with another matter, two of the sitters for the *Night Watch* gave depositions concerning the painting. Each of them declared that the painting was painted by Rembrandt, that sixteen guardsmen were portrayed in it, and that each of them paid one hundred guilders. One of them said that the price varied according to the position of the sitter in the composition.

All of these early records specify that the painting hung in the great hall of the Kloveniersdoelen. That hall, in a new wing of the *doelen*, was quite a well-known space in its day. When it was built in the 1630s it was one of the best locations in town (fig. 10). Compared to the older, late mediaeval *doelen* halls, the great hall in the new Kloveniersdoelen was bright, roomy and modern-looking. In 1636 the city government held its annual banquet in the new wing, undoubtedly in the great hall. It was the first time that this event took place outside the town hall itself. Notice that Schaep

8

5

Balthasar Florisz., *Map of Amsterdam* (1625).
Amsterdam, City Archive. Detail with the
Kloveniersdoelen and the second precinct,
where the men in the *Night Watch* lived.
Many of them were textile merchants.

called the group portraits there and in the other *doelens* 'public paintings.' The rooms in which they hung were open to visitors at most times and were used for social occasions of all kinds. The paintings in these rooms were the most accessible ones in the whole city (fig. 11).

Not only was the location exceptional. So was the ensemble of paintings in the hall. A few years after its construction, the Kloveniers decided to decorate it with a series of group portraits. This was an unparalleled campaign in the history of civic guard group portraits. Normally, each company would decide individually (perhaps in consultation with the governors of the *doelen*) if it wanted to commission a group portrait. In the hall of the new

7

Gerrit Schaep, *Manuscript notes on 'public paintings*
preserved in the 3 doelens', February 1653.
Amsterdam, City Archive. Illustrated is the page
on the paintings in the Kloveniersdoelen.

Kloveniersdoelen, though, seven paintings came into being in the same period of time. One of them was a group portrait not of a guards company but of the governors. The other six each showed one of the six Kloveniers companies. Not all of the 200 men were depicted. The captains, lieutenants and ensigns are always present, but not all the subordinate officers and troops. This effort added to the modern look of the great hall. The Kloveniers had now become the only *doelen* in the city with a set of new group portraits, painted by living masters (figs. 12-17).

Rembrandt was one of this chosen group of painters. The others were equally well known at the time. The leading figure was Rembrandt's former pupil Govert Flinck. He was the only one to paint more than one of the seven paintings. Moreover, one of these was the group portrait of the governors (fig. 22). The other commissions

went to Joachim von Sandrart, a German painter residing in Amsterdam at the time, Nicolaes Eliasz., called Pickenoy, Jacob Adriaensz. Backer and Bartholomeus van der Helst. Interestingly, only one of these men, Pickenoy, was a native Amsterdamer. Flinck and Sandrart were born in Germany, Backer in Harlingen, Van der Helst in Haarlem, and Rembrandt, of course, in Leiden. Intentionally or not, this was a demonstration of the openness of Amsterdam and its magnetic attraction for talented people from elsewhere.

Despite their different backgrounds, the six painters had certain ties to each other. All of them were related in one way or another to a powerful art dealer who lived in the same district as the Kloveniersdoelen. This man, Hendrick Uylenburgh, had brought Rembrandt, Backer and Flinck to Amsterdam and had employed them there. He lived next door to Pickenoy, who

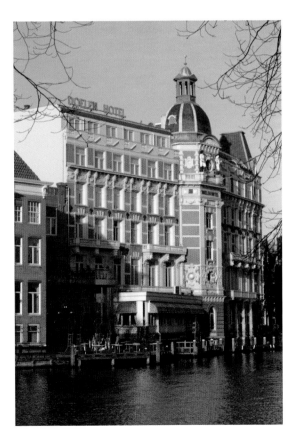

< 9

Rembrandt, *The Svych Utrecht Tower, Amsterdam*. Amsterdam, Rijksmuseum. Drawing from the 1650s. The tower adjoined the new headquarters and meeting hall of the Kloveniers, the *Kloveniersdoelen*.

10 >

The Doelen Hotel, Amsterdam. In renovated form, this is the former Kloveniersdoelen. The *Night Watch* hung in the hall behind the large windows on the ground floor.

11

The great hall of the Kloveniersdoelen, with the paintings made for it between 1639 and 1645. The location of the six group portraits of officers and guardsmen and that of the governors is known from the manuscript of Gerrit Schaep (fig. 7).

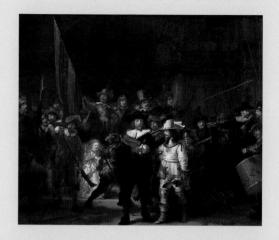

8

The styles of the six painters who made group portraits
for the Kloveniersdoelen are best compared in details.
Illustrated here are the standard-bearers from each of the
six paintings. The standard-bearer was the sub-officer
who bore the company banner. Civic guard units were so
closely associated with their banner (*vendel* in Dutch) that
they were also called *vendels* or banners.

Because they made a conspicuous target on the battle-
field, holders of this rank were traditionally chosen from
among the young, unmarried men of the company, whose
death would not bring hardship on a family. This rule was
not always abided by, mainly because of other unofficial
requirements. That is, the standard-bearer was expected
to spend a good amount of money on his equipment and
dress. In group portraits of the civic guard the standard-
bearers always cut colourful figures, which is another
reason to single them out in these details.

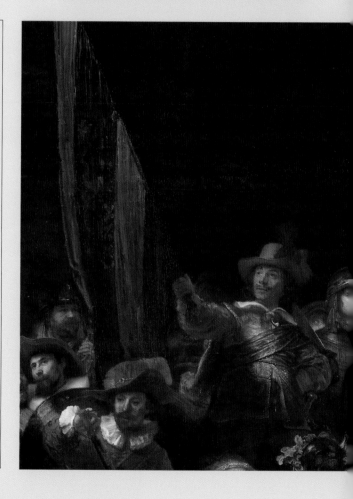

12

Above: Rembrandt, *Officers and guardsmen of the*
Amsterdam musketeers' company of Captain Frans Banning Cocq,
called the Night Watch, 1642. Amsterdam, Rijksmuseum.
Below: detail. The standard-bearer is Jan Visscher Cornelissen.

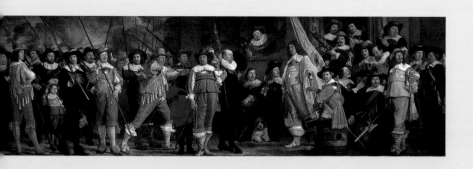

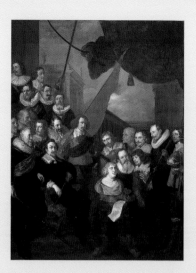

9

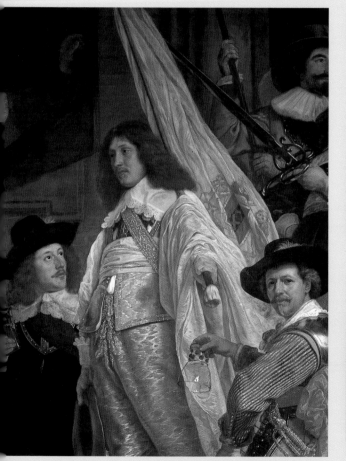

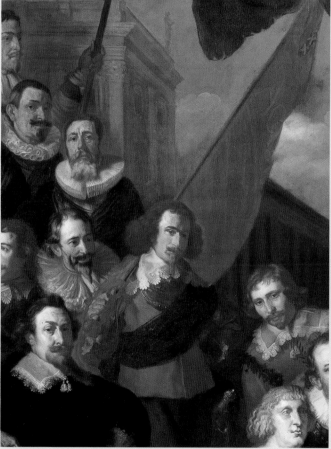

13

Above: Bartholomeus van der Helst, *Officers and guardsmen of the Amsterdam musketeers' company of Captain Roelof Bicker, 1639. Amsterdam, Rijksmuseum.*

Below: detail. The standard-bearer is Pieter Hulft.

14

Above: Joachim von Sandrart, *Officers and guardsmen of the Amsterdam musketeers' company of Captain Cornelis Bicker, 1640. Amsterdam, Rijksmuseum.*

Below: detail. The name of the standard-bearer is unknown.

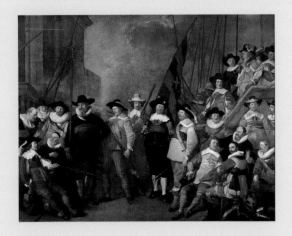

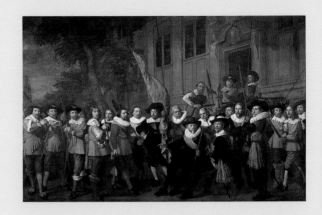

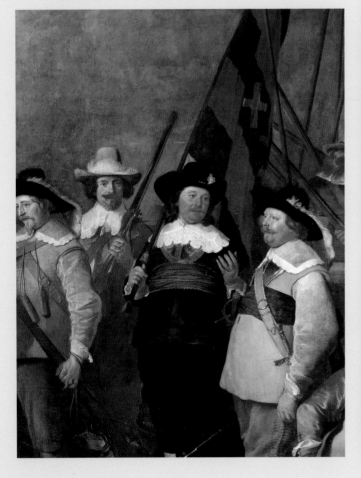

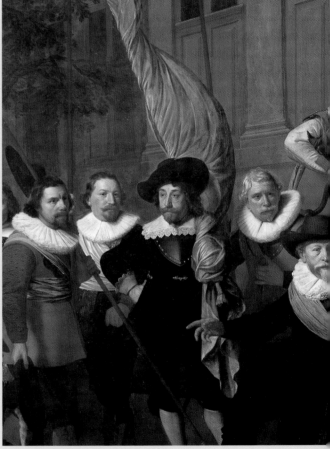

15

Above: Jacob Backer, *Officers and guardsmen of the*
Amsterdam musketeers' company of Captain Cornelis de Graeff,
1642. Amsterdam, Rijksmuseum.

Below: detail. The standard-bearer is Joachim Jansz Scheepmaker.

16

Above: Nicolaes Eliasz. Pickenoy, *Officers and guardsmen of*
the Amsterdam musketeers' company of Captain Cornelis van Vlooswyck,
1642. Amsterdam, Rijksmuseum.

Below: detail. The standard-bearer is Jan Witsen.

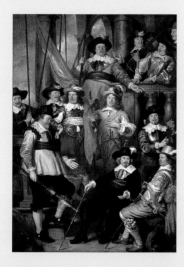

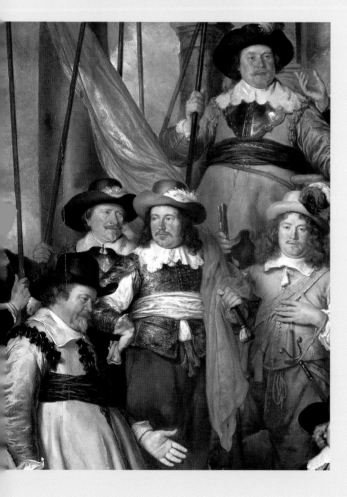

17

Above: Govert Flinck, *Officers and guardsmen of the Amsterdam musketeers' company of Captain Albert Bas*, 1645. Amsterdam, Rijksmuseum.

Balow: detail. The name of the standard-bearer is unknown.

was the master of Van der Helst. Uylenburgh may well have brokered the commissions, assuring the patrons of good quality and – a perennial problem with large projects – prompt delivery. We know from an entertaining pair of depositions that timely delivery was an issue for the guardsmen. It seems that Bartholomeus van der Helst had made a bet with a patron of his that his old teacher would not complete his group portrait on time. The bet went like this: if Pickenoy delivered by July 28, 1642, Van der Helst would not charge for a group portrait he was making for the patron; if he did not, the patron would pay double for it. In fact, Pickenoy did bring his canvas to the Kloveniersdoelen before the 28th. Still, Van der Helst was not ready to concede defeat. He claimed that the painting was not yet finished, and that Pickenoy had continued to work on it. Pickenoy denied this vociferously. He said that he had had the painting brought to the new Kloveniersdoelen on July 10th and that 'neither on July 28th nor later - in fact, not even in the preceding days - did he change the painting or work on it. The painting was actually completed before July 16th, as the sitters themselves wished and commanded.'

If the painters who decorated the new hall were not Amsterdamers, the sitters most decidedly were. Every one of the captains and lieutenants was not only born in the city, most of them were related to each other. Amsterdam was ruled by a small number of clans that were always jockeying for position. As a member in good standing of a ruling clan, an Amsterdam male could be assured of support in his career and his political ambitions. The captains of the six companies portrayed in the Kloveniersdoelen were in that fortunate position. When they were painted, most had been alderman of Amsterdam, but none had yet been a burgomaster (lord mayor), the highest office in the city. Captaincy of a civic guard company was one of the stepping stones on the way to high office, and four of the six

Cornelis and Andries de Graeff were brothers. Cornelis Bicker van Swieten was a cousin of the two brothers. Frans Banning Cocq's wife was the sister of Cornelis de Graeff's first wife. The family ties between these men have been brought into connection with their portraits and those of other members of the clan by the Amsterdam archivist S.A.C. Dudok van Heel. He also pointed out that the painters Cornelis van der Voort and Nicolaes Eliasz. Pickenoy occupied the same house, Sint-Anthoniebree-straat 1. Between the time these two artists lived there, it belonged to Hendrick van Uylenburgh, in whose studio Rembrandt worked. The *Night Watch* was painted in the house next door, Sint Anthonisbreestraat 3.

<18

Cornelis van der Voort, *Cornelis Bicker van Swieten* (1592-1654).
London, Johnny Van Haeften Ltd. Inscribed *Aetatis suae 26 Anno 1618*, meaning that the sitter was 26 years old when the painting was made in 1618. Bicker's 19-year-old wife Aertgen Witsen was also painted at the same time, in a companion portrait.

19

Nicolaes Eliasz. Pickenoy, *Cornelis de Graeff* (1599-1664).
Dated 1636 on the back, as is the companion portrait of de Graeff's wife Catharina Hooft, who was 19 years younger than he. Berlin, Gemäldegalerie.

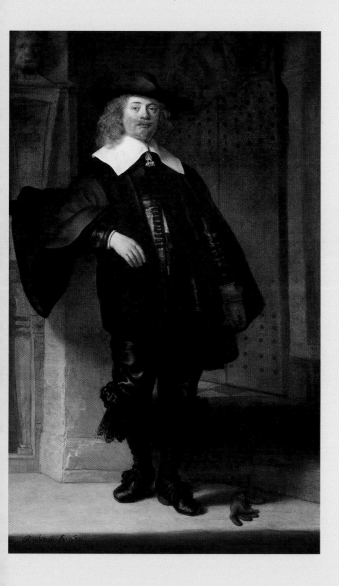

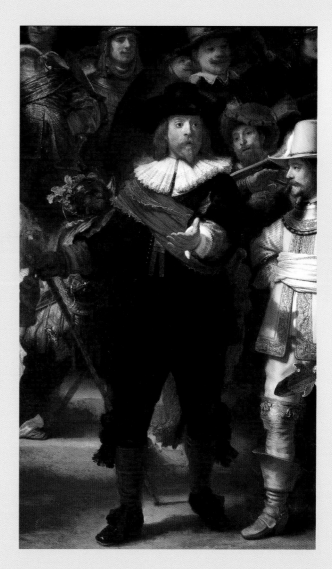

20

Rembrandt, *Andries de Graeff* (1611-1678).
Signed and dated 1639. Kassel,
Gemäldegalerie Schloß Wilhelmshöhe.
This painting was rejected by the sitter.
Rembrandt had to sue him to take
possession of it. Rembrandt won the case,
but it was a Pyrrhic victory. Never again
was he commissioned to paint a powerful
Amsterdam officeholder.

21

Rembrandt, *Frans Banning Cocq* (1605-1655),
detail of the *Night Watch*. Signed and dated 1642.
Amsterdam, Rijksmuseum. A full-length standing
portrait of Frans Banning Cocq hung with a portrait
of his wife in the hall of the family house, Ilpenstein,
alongside other portraits of the same kind. In 1872
the series was dispersed and the portraits of Banning
Cocq disappeared from sight. His image in the *Night
Watch* fits well into the sequence of family portraits.

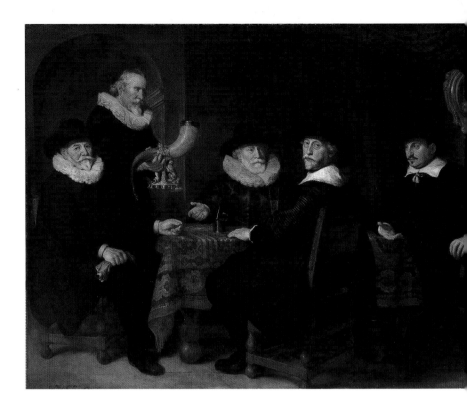

14

captains were on the way to that high dignity. Cornelis de Graeff, the head of the clan, became burgomaster in 1643, his brothers-in-law Cornelis Bicker in 1646 and Frans Banning Cocq in 1650, and his ally Albert Bas in 1647.

The great hall of the Kloveniersdoelen, then, was a gallery of the coming men of Amsterdam. Fittingly, they were painted by the leading artists of the city. Rembrandt seems to have taken account of the political status of his main sitter in his choice of pose and stance. The full-length, freestanding figure of Frans Banning Cocq belongs not only to the tradition of Amsterdam guard captains, but also to a dynastic tradition. For several decades, men in the De Graeff clan had commissioned full-length portraits of themselves, in a fashion that before then had only been practiced by aristocrats (figs. 18-20). All of the paintings came from the same two neighboring ateliers at Sint Anthonisbreestraat numbers 1 and 3. Number 1 belonged first to the

painter Cornelis van der Voort before being taken over by Hendrick Uylenburgh. Number 3 is the house bought by Rembrandt in 1639, where the portrait of Andries de Graeff and the *Night Watch* were painted. Seen in isolation, Banning Cocq fits well in the row of full-length, life-size portraits of Cornelis Bicker by Cornelis van der Voort (1618), Cornelis de Graeff by Nicolaes Eliasz. Pickenoy (1636) and of his brother Andries de Graeff painted by Rembrandt himself in 1639.

Although no contract for the commission has come down to us, two precious documents concerning the price paid for the *Night Watch* were drafted in 1659. One of the guardsmen said that 'he was painted and portrayed by Rembrandt van Rhijn, painter, with other persons of their company and corporalship, sixteen of them, in a painting now standing in the great hall of the Kloveniersdoelen and that each of them, as far as he the deposant remembers, paid for being painted the sum of one hun-

dred guilders on average, one paying more and the other less, depending on their place in it.' The other deposant said that 'the painting cost the sum of sixteen hundred guilders.' One hundred guilders accords with Rembrandt's normal fee for a half-length portrait. The extra work that went into the *Night Watch* must have been charged to the artist's pride and desire to stand out from the rest. Whether the captain and lieutenant paid an additional sum we do not know.

Rembrandt's situation

Unlike most of the other painters in the loveniersdoelen commission, Rembrandt does not seem to have had friends of his own in high places. His most important contact in the artistic-political complex of the city was the above-mentioned Hendrick Uylenburgh, who was his wife's cousin. When Rembrandt moved to Amsterdam from his home town Leiden in the early 1630s, it was to Uylenburgh's studio that he came. As it happens, his first public painting in the big city was a group portrait,

though not of a civic guard company. It shows the Amsterdam town surgeon Dr. Nicolaes Tulp in the course of an anatomical demonstration, with a small, attentive audience (fig. 23). There are no documented reactions to this painting from Rembrandt's time, but there is every reason to believe that it made a major impression on contemporaries. For years from the time it was painted Rembrandt was the most sought-after portraitist in Amsterdam, one of the richest cities in the world.

The prices he charged for his portraits reflected this. For a large standing portrait like that of Andries de Graeff, the charge would be five hundred guilders. This is the amount of money that a skilled craftsman or a minister in the Reformed Church would earn in a year.

23
Rembrandt, *The anatomy lesson of Dr. Nicolaes Tulp.*
Signed and dated 1632. The Hague, Maurithuis.

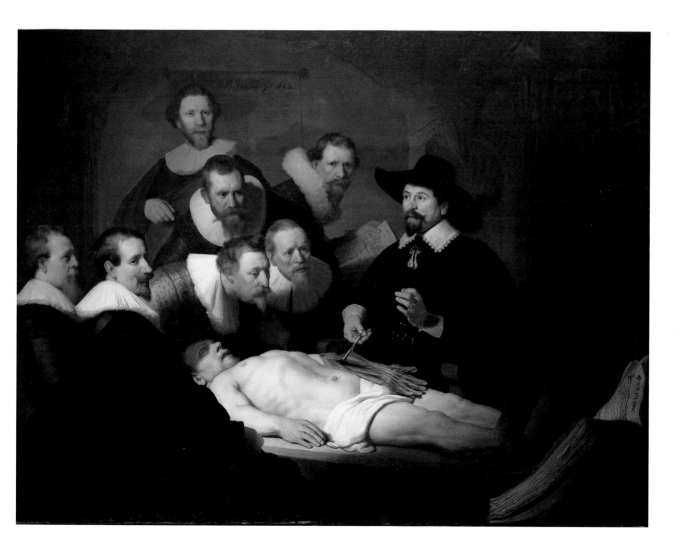

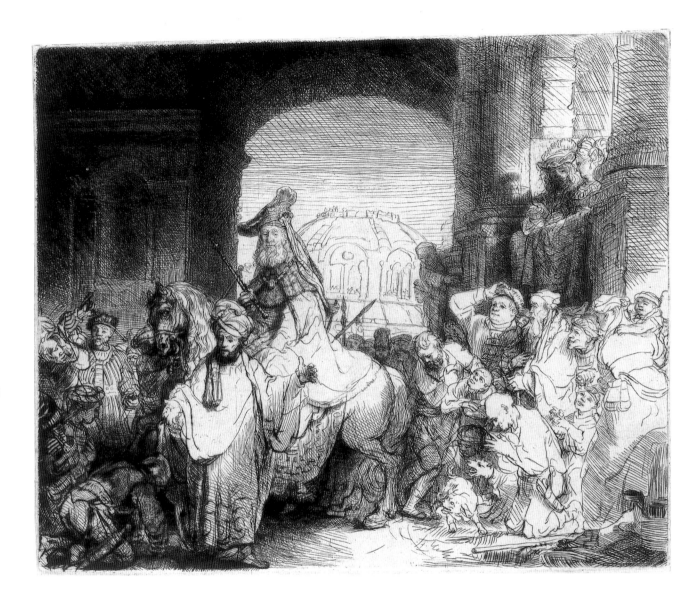

24

Rembrandt, *The Triumph of Mordechai*.

Etching dating from ca. 1641.

Amsterdam, Rijksmuseum.

25>

The inventory of Rembrandt's paintings,

drawn up in 1656, included a painting called

'The concord of the state'. It is thought to be

this panel, dated 164[2?], a political allegory

whose precise meaning continues to elude us.

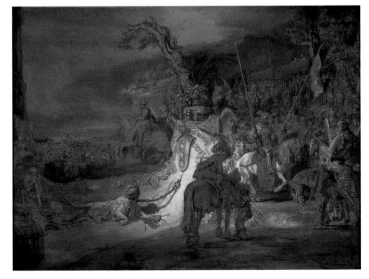

embrandt's sitters came from all the reli-ous denominations of the cosmopolitan etropolis: wealthy Calvinists, Remon-rants, Catholics, Mennonites and Jews d had themselves painted by Rembrandt. he himself went to church in the 1630s, e do not know where he prayed.) He was ithout question a society portraitist in his period. But he was never only that. He so painted subjects from the Bible and om mythology, allegories, landscapes, lf-portraits and people in fancy costume. is etchings cover an equally wide range of bjects. One of the fascinations of Rem-andt's art is that the categories overlap d enrich each other. A striking example the etching of an Old Testament subject,

The triumph of Mordechai, from the period when he was working on the *Night Watch* (fig. 24). The architecture and the dynamics of the composition, with a cortege moving from the center of the scene forward and right, bear a general resemblance to the *Night Watch*. Rembrandt's use of the white of the paper in the etching is the equivalent of the black in the background of the *Night Watch*. They are blank, but nonetheless do not create a vacuum in the space.

Rembrandt's painting of the Mennonite merchant and preacher Cornelis Claesz. Anslo displays another kind of connection with the *Night Watch* (fig. 26). The extended left hand, like that of Banning Cocq, seems to break through the picture plane into the

space of the viewer. Like the captain as well, the preacher is shown in the act of speak-ing. These works give a good indication of what people expected from Rembrandt in these years: a dramatic treatment of his subject, filled with movement and emo-tion. They make virtuoso use of technique, suggesting more than the sum of the details.

Rembrandt was talked about for other things beside his art. He was also a glam-orous figure on the Amsterdam scene. Between 1632 and 1642, from his twenty-sixth to his thirty-sixth year, Rembrandt was a young millionaire. He and Saskia, whose deceased father had been a burgo-master of Leeuwarden, lived so well that

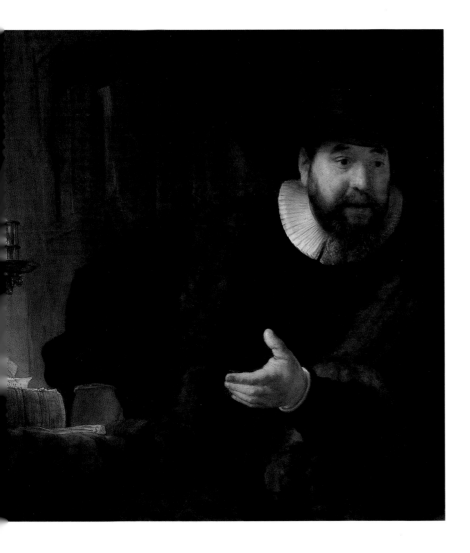

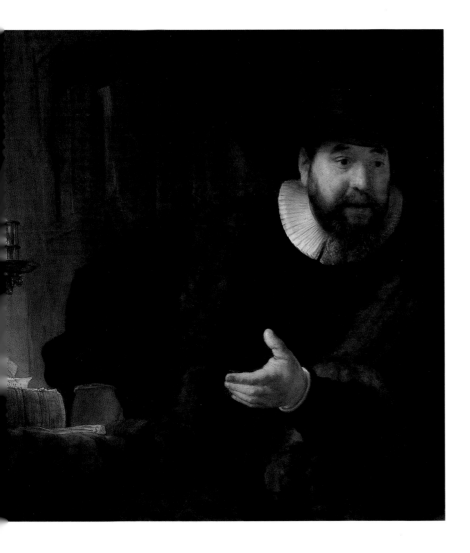26

Rembrandt, *The Mennonite preacher and cloth merchant Cornelis Claesz. Anslo*, detail.
Signed and dated 1641. Berlin, Gemäldegalerie.
In the complete painting, Anslo is speaking to his wife. His outstretched hand and open lips, which resemble the pose of Frans Banning Cocq, led the poet Joost van den Vondel to write of this painting: 'That's right, Rembrandt, paint Cornelis' voice!'

27

The Rembrandt House in Amsterdam.
Built in 1606, the year of Rembrandt's birth. The artist
bought the house in 1639. According to Dudok van Heel,
the *Night Watch* was too big to fit into any of the rooms.
He has found evidence that the painting was made on a
platform built in the courtyard behind the house.

28>

Rembrandt, *Self-portrait*.
Signed and dated 1640.
London, National Gallery.
Rembrandt at the top of his
success, and looking it.

her relatives accused Saskia of squandering her inheritance. In 1638 the couple sued the relatives for libel, claiming that they were 'richly and abundantly endowed (for which they can never be thankful enough to the Almighty).' This was true in the year of the court case (which Saskia and Rembrandt lost). They dressed beautifully and owned a splendid collection of paintings, drawings, prints, statues, weapons and curiosities. In 1639 they bought an expensive house in a fashionable new street (fig. 27). There Rembrandt had his own reception halls, where he displayed his collection and such treasures as a set of busts of the Roman emperors. His self-portrait of the year 1640, shows him as a proud and wealthy man (fig. 28).

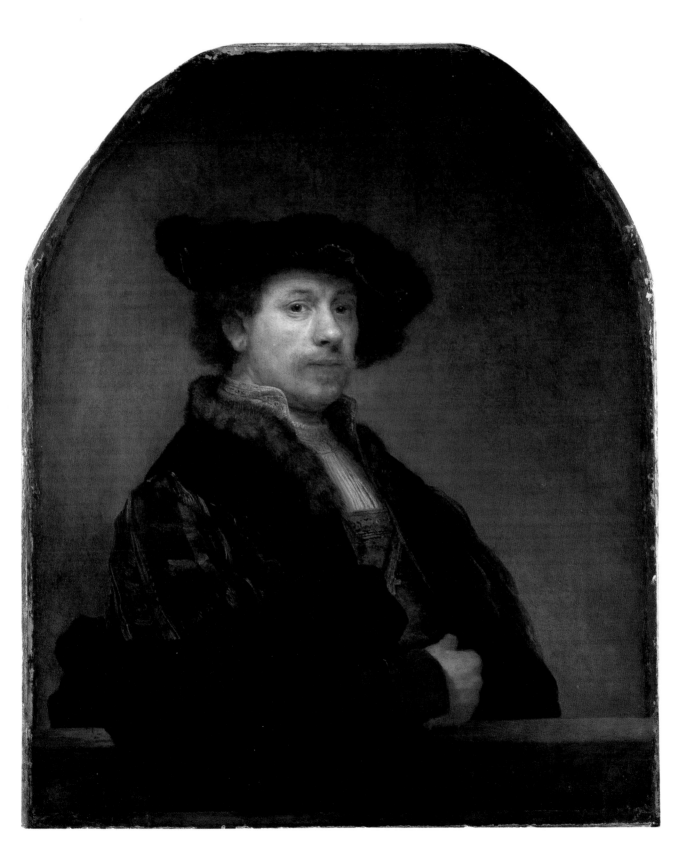

Sources

In 1961 the Utrecht art historian Emil Rez-nicek observed that the composition of the *Night Watch* bears a certain resemblance to a drawing in the Print Room of the Rijksmuseum (fig. 29). The drawing is by a Flemish artist named Jan van der Straet (1523-1605), who was also called Giovanni Stradanus and thirty other names. The drawing shows a procession in the streets of Florence, where Stradanus lived for most of his life. One is indeed struck by the similarity in the staging of both scenes, which show two central figures striding forward in front of an arch, amidst a crowd of armed men. On the right in both compositions a soldier beats the drum, and in both a number of small children are part of the cortege.

Could Rembrandt have known this composition? Perhaps not in the original drawing by Stradanus but certainly in the print published (in reverse) by Philips Galle in Antwerp in 1583, which made it widely available in the Netherlands. There are indications in other works as well that Rembrandt was aware of prints after Stradanus and that he adapted them for his own work. The print in question belongs to a series of twenty images on the *Fortunate deeds of victory and triumph of the Medici family*. It shows Cosimo de'Medici (1519-1574) entering Florence after having been crowned Grand Duke of Tuscany by Pope Pius V in Rome. If Rembrandt really meant to refer to this event in the composition of the *Night Watch*, as I believe he did, then he was playing with a powerful historical coincidence. The year before he received the commission, another Medici entry had taken place before his very eyes. On September 1, 1638, Cosimo's granddaughter Maria (1573-1642), the queen mother of France, was received in Amsterdam with the greatest public ceremony the city had ever seen. Needless to say, the civic guard was heavily involved. The day before the entry, 'there was a mighty to-do among the captains concerning who was to be first or last to march out or back. Ditto concerning where everyone was to stand, and where and when to march.' Lots were drawn, and the lead position inside the city gates went to the company depicted in the *Night Watch*, the men of the second precinct. The captain and lieutenant stood outside the gate with the burgomasters. (These were the predecessors of Banning Cocq and van Ruytenburgh.)

Considering the importance of this recent event in the life of the company, combined with the resemblance of the *Night Watch* to the entry of Cosimo de'Medici, it takes effort not to believe that Rembrandt and the guardsmen were thinking of Maria de'Medici in settling on this composition. One of the other companies of Kloveniers certainly was thinking of her.

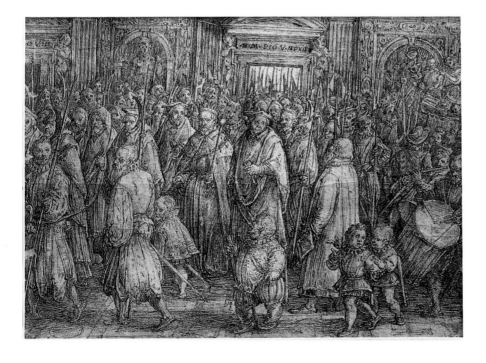

29

Jan van der Straet, also called Giovanni Stradanus, *The return of Cosimo de'Medici to Florence*. Amsterdam, Rijksmuseum. Drawing for an engraving in a series on the fortunes of the Medici family.

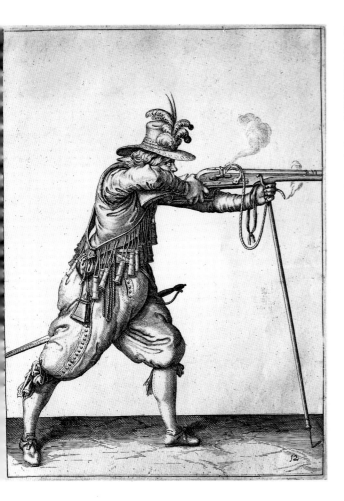

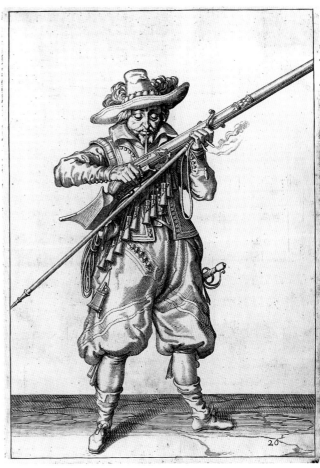

Joachim von Sandrart's portrait of the
Company of Cornelis Bicker, the men are
seated solemnly around a bust of the queen
(fig. 14). This image is a rare if not unique
representation of an outsider in an Amster-
dam civic-guard portrait. There may also
have been another portrait of the queen in
the hall. An authoritative guidebook to
Amsterdam published in 1663 says this in
so many words, although the painting
itself is unknown. In later years, it should
be added, the Medici bestowed open signs
of favour on Rembrandt. They hung his
self-portrait in their gallery of self-portraits
by famous painters. And in 1668, when
Cosimo de'Medici III visited Amsterdam,
he made a point of looking up Rembrandt,

then in his sixties and down on his luck.

Memories of the entry of Maria
de'Medici are also evoked by an unusual
feature of the Night Watch. The figures are
dressed in fancy costume and many of
them wear pieces of armour. This is not the
practice in normal civic guard portraits.
But it does jibe with the following charac-
terization of how the guardsmen were
dressed at the entry of the French queen
mother: 'They were partly armed with
pikes, partly with muskets, and they were
covered with helmets and harnesses. As for
their clothing, it varied in accordance with
either rank or individual preference; but
there was no one who had not made an
effort to appear in very beautiful apparel.'

30
Robert de Baudous after Jacques de Gheyn,
A musketeer firing his weapon, from *The exercise of arms*.
Engraving of 1607, after a drawing made in 1597.
Amsterdam, Rijksmuseum. The delay in publication
of this print was due to considerations of national
security. The information in *The exercise of arms* was
considered a military secret. Compare the boy behind
the captain (nr. 14) in the *Night Watch*.

31
Robert de Baudous after Jacques de Gheyn,
*A musketeer blowing the pan of his weapon clean of
unexploded powder*, from *The exercise of arms*.
Amsterdam, Rijksmuseum.
Compare the helmeted guardsmen behind
the lieutenant in the *Night Watch* (nr. 24).

Pointing out these ties between the Medici and the *Night Watch* and Rembrandt does not mean that the group portraits in the hall were ordered to commemorate the visit of Maria de'Medici. Nor do they mean that the painting has no other meaning than a reference to the visit. But they provide strong evidence that the event was still in the minds of all when the portraits were made.

A more obvious allusion to a visual source, one which would have been known to all viewers in Rembrandt's time, links the *Night Watch* to the manual of arms of the States army. The classic edition was one of the most famous books of the entire seventeenth century, *The exercise of arms (Wapenhandelinghe)*, published in 1607. Although none of the prints in the book corresponds exactly with a detail in the *Night Watch*, *The exercise of arms* can nonetheless be considered a source for the painting. The prints in the first part of the book break down the various steps that need to be performed in the loading of a musket, the weapon of the Kloveniers. Loading a firearm was a delicate and dangerous operation. In battle it had to be performed securely in order for the weapon to be effective. In the 1590s, during the early phases of the Eighty Years War against Spain (1568-1648), Dutch military

22

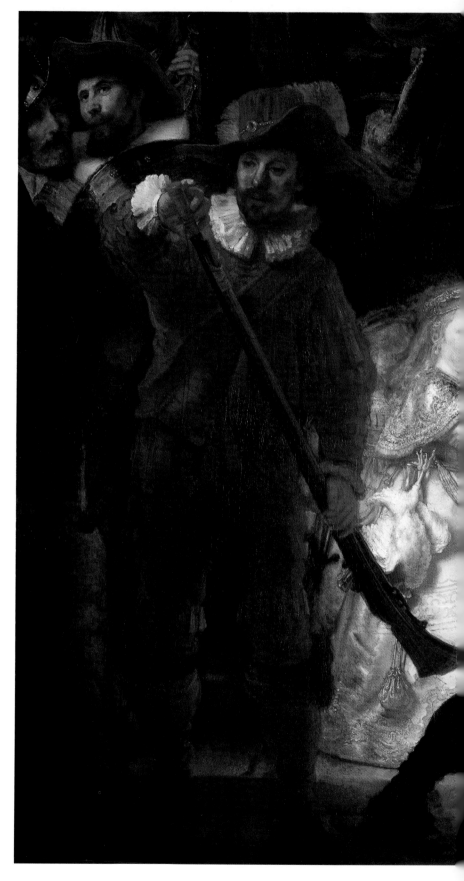

32

Rembrandt, the *Night Watch*, detail.

Amsterdam, Rijksmuseum.

The musketeer loading his weapon

takes an erroneous pose.

theoreticians realized that the musket could be used most effectively if musketeers performed their work in separate steps. After firing at the front line, a musketeer would return to the back of a line of eight soldiers, and proceed again to the front while reloading in accordance with standard instructions. This technique was known as the counter-march.

In the *Night Watch*, Rembrandt posed two musketeers in positions derived ultimately from *The exercise of arms*. Behind the captain the small figure in full armor holds his weapon in the position to fire (fig. 30). The older man in red behind Lieutenant van Ruytenburgh is blowing the pan clean of unexploded gunpowder following a shot (fig. 31). The guardsman on the left, seen in full figure, who is charging his musket from the muzzle, resembles a figure not from the book but from a lost civic guard portrait by Jan Tengnagel. The pose was misunderstood by Tengnagel, and Rembrandt copied his mistake: the stock of the musket should be held not from above but from below (fig. 32).

The exercise of arms also contains a drill for the use of the pike. In this too Rembrandt varied the images from the manual. The pikeman on the right, with the feather in his cap, enacts the first motion of advancing the pike; the man above the captain, in the high hat, is engaged in the second motion of shouldering the pike; the helmeted guardsman above the lieutenant, finally, is performing the second motion of porting the pike (fig. 33).

Rembrandt made no attempt to coordinate these actions. The binding principle in his painting is not the logic of exercise or military discipline. The unifying concept is the captain's command, and the tactics of artistic composition.

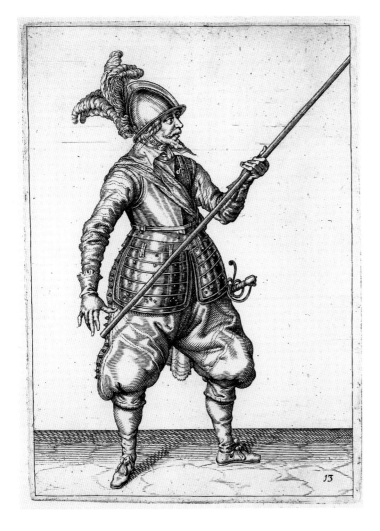

33

Robert de Baudous after Jacques de Gheyn,
*A pikeman demonstrating the exercise known as 'Port the pike
(the second motion),' from The exercise of arms.*
Amsterdam, Rijksmuseum.
Compare the guardsman (nr. 25) behind
the outstretched hand of Sergeant
Rombout Kemp (nr. 5).

What do we see?

The *Night Watch* is a somewhat difficult painting to interpret. It is too large and complex to take in all at once with the eye, and photography always lets us down as well. The space in which the action takes place is not easy to grasp, many details are obscure, and large parts are quite dark. To those who try to pin down the meaning of difficult passages, it may be a consolation to know that even the experts are often at a loss. Books and articles on the painting are full of corrections of earlier interpretations. Some of the corrections become standard wisdom. Most do not, however, and in their turn are criticized by later writers. Interpretations of parts of the painting are just that – interpretations, not straight ascertainments of fact.

In order to specify the details in this fascinating painting, we will build it up systematically. We will first look at the location without people; then identify the figures section for section. A great help in seeing the painting more clearly is provided by a later print of the composition, in a first state, resembling a line drawing (fig. 34). In addition, the draftsman Jorien Doorn

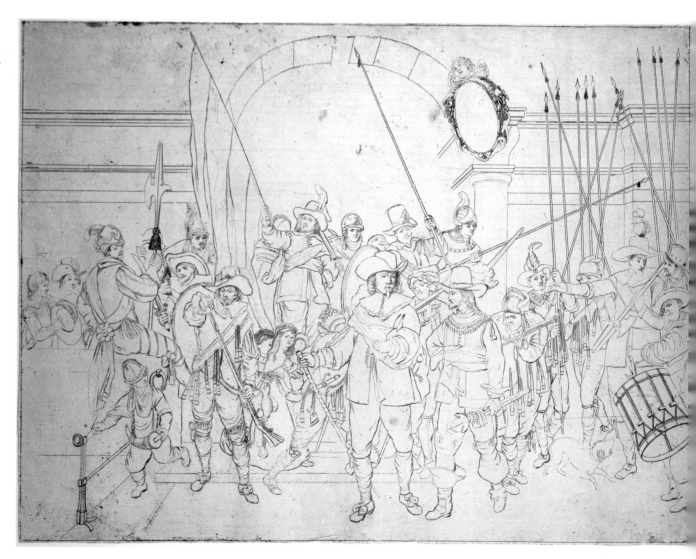

has made new sketches that interpret the space as she and I see it (figs. 35, 39-41).

The location where the scene takes place (fig. 35) lies before a wall pierced by a round arch. Beyond the arch – a big chunk of the picture space – is nothing but darkness. The wall is richly articulated with projecting and receding columns, piers, friezes and bands, in a classical style known as the Tuscan order. A closed window gives onto the scene in the upper right. At the springing of the arch, on the right, is a concave oval plaque framed spectacularly with the head of a cherub and a wreath. On it the names of the sitters are inscribed. As we know, this striking element of the painting is not by Rembrandt (fig. 62).

35

Reconstruction of the architectural setting of the *Night Watch*, based on examination of the painting and photographs.

34

Lambertus Claessens, Etching of the Night Watch, first state (1797). Amsterdam, Rijksmuseum. The artist came from Antwerp in the Southern Netherlands and studied printmaking in London with the Italian artist Gaetano Stefano Bartolozzi. His print of the *Night Watch* dates from the year when he moved to Amsterdam. It was probably made from an early copy, since it includes the edges that were trimmed off in 1715. The print is particularly precious in the impressions of the first state, without the modelling and shading. It shows the outlines of the architecture and figures more clearly than the completed print or photographic reproductions of the painting. For an illustration of the print with the figures numbered and identified, see the flap at the end of the book.

In front of the wall a flight of broad, shallow stairs descends to the foreground area. On the left, the stairs abut a parapet with a stone post and a heavy iron ring; on the right, they end behind Lieutenant van Ruytenburgh. Only the two front treads can be seen, but the high positioning of the figures immediately in front of the arch suggests that they are standing on steps. In front and to the right of the flight of steps is a trodden earth ground with a few fragments of stone tiles. The setting bears a general resemblance to certain known structures. It is not dissimilar to the Sint Anthonispoort, where the civic guard stood watch (fig. 37), or to the temporary arches erected for the entry of Maria de'Medici, where they proudly lined up to greet her (fig. 38). However, we do not have a perfect match. For all its seeming concreteness, the setting may be imaginary.

On this stage are placed two different kinds of figures and an assortment of weapons. The second kind of figures in addition to the officers and guardsmen are extras inserted by the artist. This is not unique in Amsterdam civic guard portraits, but no other artist before or after Rembrandt made such liberal use of the device. Sixteen have been identified, as many as the number of guardsmen. In identifying the figures, we will follow the numbering used by Egbert Haverkamp Begemann, the author of an essential book on *the Night Watch*. As in his book, the numbers are placed for the sake of legibility on a reproduction of the first state of the etched copy by Lambertus Claessens. The complete print, with legend, is reproduced on the flap at the back of the book.

The captain and lieutenant occupy front

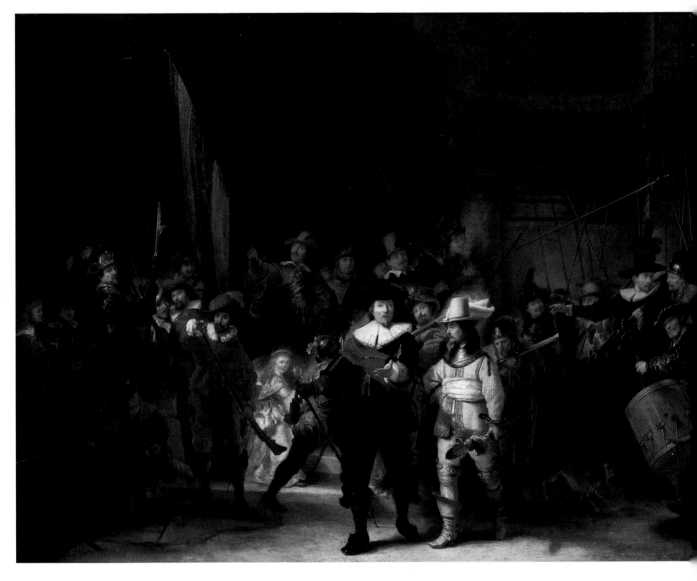

36

Gerrit Lundens (?), *Small painted copy of the Night Watch.*

Amsterdam, Rijksmuseum.

This copy was made before the medallion with the

names of the sitters was added and before the upper

and side edges were removed.

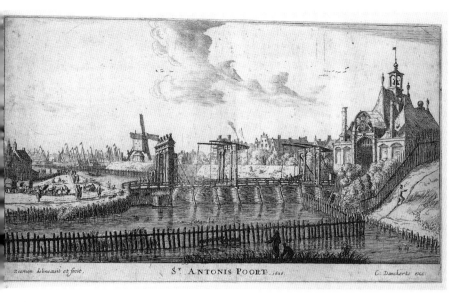

S.ᵗ ANTONIS POORT. 1636.

37

Cornelis Dankerts, *The St. Anthonispoort
(St. Anthony Gate) in Amsterdam*, 1636. Amsterdam,
Koninklijk Oudheidkundig Genootschap.
Etching from a series of 16 views.

38

Salomon Savry after Jan Martsen de Jonge,
*One of the temporary gates set up in Amsterdam
for the glorious entry into the city of Maria de' Medici,
the queen mother of France*, 1638.
The Hague, Royal Library. Etching from the
book by Caspar Barlaeus on the entry of
Maria de' Medici into Amsterdam.
There is every reason to assume that memories
of this event, in which the entire civic guard
participated, reverberate in the *Night Watch* and the
other group portraits for the Kloveniersdoelen.

tage center, in full length and full light
ig. 39). Frans Banning Cocq (1) has been
alled an armed civilian, and Willem van
uytenburgh (2) a true military man.
anning Cocq is dressed in distinguished
lack, with a broad, flattish ruffled collar
nd a red military sash. He is armed with a
word and wears a gorget; in his right hand
e carries a baton as a sign of authority and
glove. His left hand is extended in a com-
anding gesture and his mouth is open
if to give the order to march. Beside him
the gloriously dressed lieutenant, also
earing a gorget and carrying a weapon
nown as a partisan. This is a broad-bladed
ear with pointed wings. The partisan
at Lieutenant van Ruytenburgh holds
his hip has gold-and-blue tassels in the
lors of the Kloveniersdoelen. In Rem-
randt's time the partisan was no longer
ed as a weapon. It was a ceremonial
ject borne by lieutenants in the States
my as well as the civic guard. The exquis-
detail and correctness in the depiction
van Ruytenburgh's partisan, including
decorated shaft, is exceptional in the
ght Watch. In general, as the Rijksmuse-
specialist in weaponry Bas Kist has
itten, the weapons are painted rather

sloppily and too small to boot. The X-rays
show that the partisan too was undersized
at first, and that it was enlarged twice.

The arrangement of the guardsmen in
the *Night Watch* can be better understood by

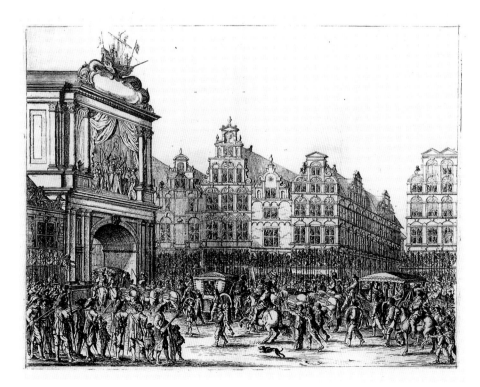

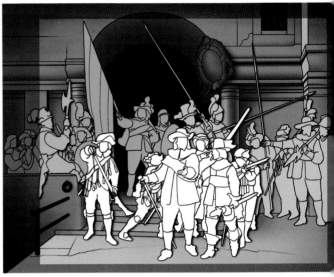

39

Reconstruction of the setting of the *Night Watch*,
with the captain, the lieutenant and the sub-officers
behind them.

40

Reconstruction of the setting of the *Night Watch*, with
the sub-officers and the guardsmen behind them.
The musketeers are white, the standard-bearer and his
protectors blue and the pikemen violet.

focussing on the weapons they bear and the officers they serve (figs. 40 and 41). There seem to be three main groups, the musketeers, the pikemen and the rondachers. Musketry is concentrated in four figures behind the captain and lieutenant: the full-length man in red loading his musket (10), the armed musketeer firing the only shot in the painting (14), and the older guardsman blowing the loose powder off his musket (24). The intense-looking man behind the chief officers has been identified as the captain of arms (22). With his right hand he seems to support the angle of the musket being fired in front of him. His hidden left hand holds up the double-edged sword that emerges behind Lieutenant van Ruytenburgh.

Muskets are also held less conspicuously by two guardsmen in the left background (6 and 9) and one in the right (27).

Musketeers 9, 10 and 24 are equipped with a gunfork or musket rest, a u-shaped metal device that would be attached to a pole and used to steady the heavy weapon for firing. Finally, there seem to be three parallel musket barrels raised into the air in the right background. This is a mysterious detail, since there is no space indicated where the bearers of these weapons might be standing. To the barrels of several of the weapons loading rods are attached.

All the pikemen occupy a space extending from the center to the right of the composition, one plane behind the four active musketeers. The officer in charge in this area is Sergeant Rombout Kemp (5), who holds a halberd in his left hand and raises his right hand in a gesture of command. The halberd was an outdated cutting weapon associated with the rank of sergeant. Both sergeants in the *Night Watch*

carry one. With its perpendicular hook, the halberd was developed to help infantrymen pull knights off their mounts. By the seventeenth century it was used mainly by low-ranking officers to keep their troops in line. Kemp seems to be giving instructions to the helmeted man behind him (28), who from the position of the pike reaching into the painting appears to be at the head of further troops out of the picture on the right. The head of one member of this troop can be seen in the old print after the *Night Watch*, on the stroke cut off at the right (29). The pike group further includes the guardsman with a plumed hat (25), the one with a fancy helmet (23) and the prominent pikeman in the center, with a tall hat (20). (The X-rays reveal that his hat too originally had a plume.) In this section ten additional pikes lean against the wall at the right. Pikes were generally about six meters

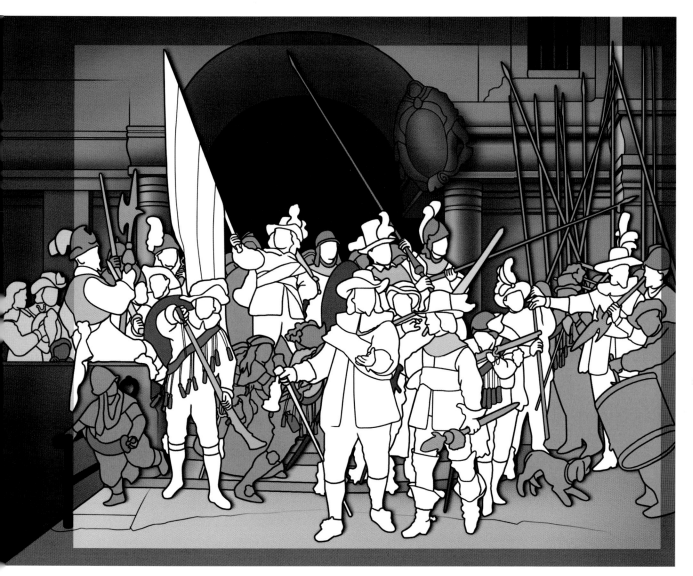

41

Sketch of the figures in the *Night Watch*,

with the weapons coded in colour.

With thanks to Bas Kist.

☐ Guardsmen		Musket	
Additional figures		Gunfork	
Baton		Pistol	
Partisan		Powder horn and	
Halberd		powder cartridges	
Double-edged sword		Rondache	
Sword		Breastplate, leg armor	
Pike		Iron gorget	
Lance		Helmet	

long, rather longer than they appear in the painting.

The central group is dominated by the ensign or standard-bearer, Jan Cornelisz. Visscher (3). He has raised the troop banner high and looks up at it with satisfaction, his left arm crooked at his waist with a touch of swagger. Because the standard-bearer went into battle lightly armed, he was always surrounded by a guard of ron-dachers, who take their name from their round shields. Visscher is indeed backed up by a helmeted rondacher with a backsword (18) and flanked by another, a man named Herman Wormskerck (8), who also carries a sword. The other fighting men surround-ing the banner are an older man in a point-ed helmet, holding a sword (7), and a mus-keteer with a gun-fork and a slow-match musket (9).

Sergeant Reijer Engelen is the man at the far left (4), in a gilt helmet and holding a halberd. Engelen is sitting on a massive stone parapet. He seems to be looking at his superiors for instruction. Behind him were two guardsmen who were cut off the painting in the operation of 1715.

Seen in this way, the Night Watch has a somewhat functional structure and an understated chain of command. But it has more. Each of the sectors also has a comple-ment of extra figures who were not guards-men. These figures add immense interest to the painting, even competing for atten-tion with Frans Banning Cocq's Kloveniers themselves.

The Night Watch extras in their turn fall into two categories. (The barking dog is in a category of his own.) There are four full figures playing significant roles in the action and twelve fragments of personages who fill in nooks and crannies in the com-position.

The extra on the right is a drummer who was not a member of the company (30). He has been identified as the 52-year-old Jacob Jorisz. In later years he testified that he worked for Banning Cocq as a

drummer. It is at him that the dog seems to be barking. The remaining two figures on the ground floor are both boys in armour. In the left sector a small boy in a helmet runs off to the right with a powder horn (11), looking over his shoulder. An older boy half hidden behind the central figure, Banning Cocq, is actually firing a musket (14). Finally, under the towering figure of the ensign, on the first step, a little girl in a brilliant satin dress, with a chicken and a pistol strapped to her waist, is striding off to the right (13).

This brings us to the final category, the fragmentary figures that are neither por-traits nor bearers of a specific meaning. There are twelve of them. From left to right: a child on the section removed in 1715 (34); a musketeer hidden behind Reijer Engelen's halberd (6); a second girl behind the famous girl we have already seen (12); three heads of men surrounding Ensign Jan Visscher (15, 16, 17); the fore-shortened head of a man above Banning Cocq's hat (19); another on the other side of the pikeman in the tall hat (21); a pike-man whose head can be made out behind the hand of Rombout Kemp (26); a fancily dressed man above Kemp's arm (27); a head behind the latter (31); and a head to the right of Kemp (31). The presence of these fragments allows Rembrandt to place the paying sitters in varied poses and positions without creating gaps in the composition. They add mass and picturesqueness to the event.

The headgear in the Night Watch is no less varied and imaginative than we expect of Rembrandt. There is not a bare head in the painting, and everyone has a cap or hat or, for the little girls, a wreath, of another cut. Seven men and the two boys wear hel-mets, each of a different type. In itself this is not unrealistic. There were no uniforms in the civic guard, and the officers and men had to provide their own armor.

This description, even though it does not go into detail concerning costume or

pose or lighting or architecture or color, indicates how many choices Rembrandt had to make in designing and painting the Night Watch. He certainly did not make things easy on himself. Or on us.

What don't we see?

What you see is not always what you get. The visible details of the *Night Watch* convey certain literal information, but they do not tell us all we want to know. It suggests meanings that go beyond description. Who wouldn't like to know about them? Why is Frans Banning Cocq holding a glove so conspicuously? Why is there a little girl in the painting and why is the musket being fired by a little boy? Is the *Night Watch* an evocation of a real event, an allegory, a group portrait, or a mixture of the three? The favoured opinion at the moment is that the *Night Watch* is a 'role portrait,' a group portrait in which the sitters are depicted less an individuals than as actors in a dramatized civic function. Do light and dark play a symbolic role in the painting? Is the form and placing of the partisan in front of the groin of Willem van Ruytenburgh a phallic symbol?

There are few definite answers to these questions and more like them. Concerning the little girl we can say that the chicken at her waist resembles the emblem of the Kloveniers (The word was often associated with the Dutch word for claw.) Because the painting does not conform to an existing model or code, it is open to interpretations of all kinds, which cannot be proven wrong. Those conclusions can be very meaningful to the viewer, and may inspire new artistic creations. This can happen even if the interpretations are probably wrong. Gustav Mahler, for example, cited the *Night Watch* as a source of inspiration for the *Nachtmusik* in his Seventh Symphony, even though art historians agree that the painting is not a night scene. Jean-Luc Godard opens his film *Passion* with an extensive passage on the *Night Watch*, based on the old myth that the underlit sitters were displeased with the painting.

Personal reactions may also lead to acts of destruction. The man who attacked the painting with a knife in 1975 concentrated on the figure of Frans Banning Cocq for symbolic reasons. He was convinced that Willem van Ruytenburgh, in his golden suit, was an angel, and Frans Banning Cocq, in black, the devil.

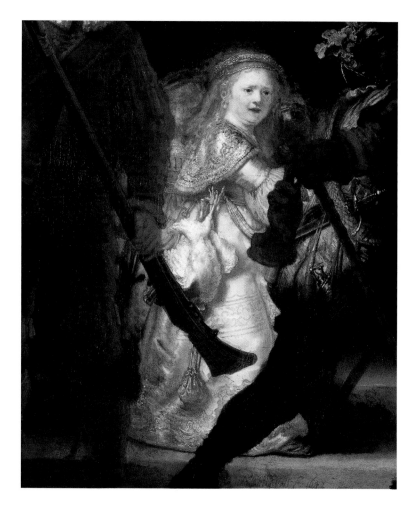

Rembrandt, *The Night Watch*, detail.
No viewer can fail to be fascinated by
the pretty girl in the glittering silk dress
with a dead rooster at her waist. She is
though to personify the civilian camp
followers who provided troops in the
field with food and necessities.

Technique

The art historian who has done more work than anyone else on Rembrandt's painting technique is Ernst van de Wetering. We can do no better than to follow his reconstruction of the genesis of the *Night Watch*.

Although Rembrandt must have begun with a conception of how the finished painting would look, he does not seem to have worked from drawings of the entire composition. Instead, he sketched it in full size on the canvas, over a dark ground, in a thin monochrome paint layer known as 'dead colour.' Here and there he added highlights or touches of colour in order to clarify obscure passages.

With the entire work before his eyes in this preliminary form, he then worked the painting up with pigments and in full detail (fig. 43.) He did this from back to front. That is, he first painted the architecture and the background figures, leaving reserves open for the foreground motifs. Rembrandt worked sparingly with paint, not needing more than one or two layers to achieve the tone he desired. As he went, he took account not only of the details and colors of the local areas, but also the spatial effect of the painting as a whole. To preserve the illusion of depth, he adapted and adjusted the relative size of the objects and figures, the effect of the intervening air on our view into distance, the broadness of his brushstrokes, the brightness or darkness of individual passages and other factors. Comparing various parts of the painting, one is struck by the great differences in resolution, coloring and surface treatment between them. The earliest comment on the painting by a qualified restorer, Jan van Dijk (1758), says, 'This painting is admirable, in respect of the great power and especially of the brushwork. It is a strong sunlight scene, done very forcefully in the paint, and it is most amazing that with so much coarseness there could be so much finesse, for the embroidery on the camisole or buffcoat of the lieutenant is so high in paint that one might grate a nutmeg on it.'

When all the sections of the painting were completed, Rembrandt added the finishing touches, mainly delicate white highlights. The surface was then covered with a varnish in order to protect it and to increase its luminosity.

This procedure was the same that Rembrandt employed on his earlier paintings. It did not involve any innovations or secret ingredients. According to van de Wetering Rembrandt painted the *Night Watch* entirely on his own. The need to achieve balance throughout the painting made it too difficult to delegate parts of it to assistants.

For a cross-section of the layers of canvas, primer, paint and varnish in the *Night Watch*, see fig. 44, prepared for this publication by Jorien Doorn.

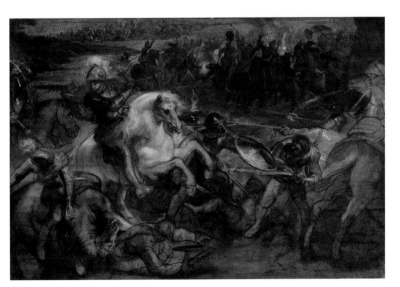

43

Peter Paul Rubens, *King Henry IV of France at the Battle of Paris*, 1625. Antwerp, Rubenshuis. This incomplete oil painting shows how the *Night Watch* could have looked as Rembrandt worked on it.

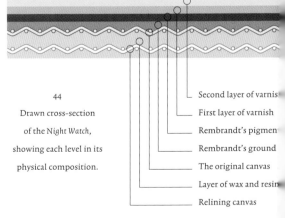

44

Drawn cross-section of the *Night Watch*, showing each level in its physical composition.

Second layer of varnish
First layer of varnish
Rembrandt's pigment
Rembrandt's ground
The original canvas
Layer of wax and resin
Relining canvas

The name

The earliest recorded use of the name *Night Watch* for Rembrandt's civic guard portrait dates from 1797. On October 27th of that year, the National Council of the Batavian Republic registered the receipt of an etched copy of the painting by Lambertus Claessens. In an accompanying letter, Claessens calls the painting 'De Nagtwagt.' (Today, the Dutch word is spelled Nachtwacht.) In itself, this is not necessarily a misunderstanding. The first duty of the civic guard was to stand watch at particular locations in Amsterdam. The ordinance of 1650, signed by none other than Frans Banning Cocq as head of the War Council, speaks of a day watch and a night watch. However,

since that is not what the company is doing in the painting, it seems likely that the name was not employed until people began to think that of it as an actual night scene. This impression too is not really contradicted by the painting. The blackness inside the gate seems to suggest this. Although everyone is now convinced that the painting is a day scene, no good explanation for the darkness beyond the arch has ever been advanced.

The idea that the painting depicts a night watch probably originated before 1758. In that year, the city restorer Jan van Dijk wrote that the painting 'shows a militia company marching out. But because of

the great deal of boiled oil and varnishes that have from time to time been brushed over it one was unable to see what kind of company...' Van Dijk then specifies that it is painted in 'strong sunlight,' as if to contradict the opinion that it is a night scene.

This misidentification provided later writers on the painting with an easy target for a bit of debunking. Especially on occasions when the painting was cleaned, observers would take pleasure in calling out in choir 'But it isn't a night watch at all!'

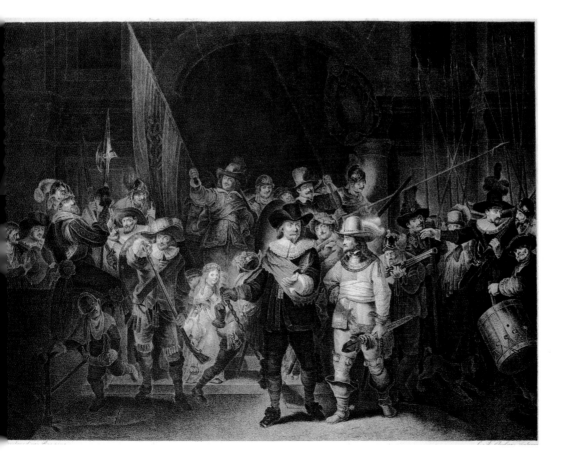

45
Lambertus Claessens, *Etching of the Night Watch*, last state (1797). Amsterdam, Rijksmuseum. Reproductions of the *Night Watch* such as this one played an important part in turning the painting into an icon of Western culture.

Where the Night Watch has hung

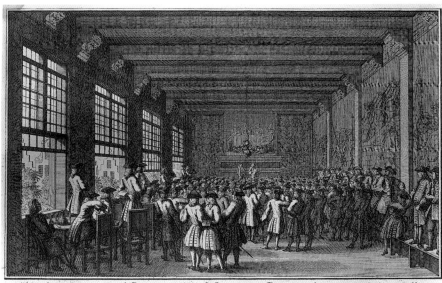

Vergadering der PATRIOTTEN op de BURGERZAAL in de CLOVENIERS DOELEN te AMSTERDAM, in Augustus A.° 1748.

<46
The great hall of the Kloveniersdoelen,
Amsterdam, 1748. Amsterdam, Rijksmuseum.
From a book on the burghers of Amsterdam,
showing a meeting of the Patriot party.
The group portraits were gone by then, and the
artist gives a wrong impression of how they hung.

From 1642 until 1715, the *Night Watch* hung in the great hall of the Kloveniersdoelen (fig. 46). By 1715 the civic guard was no longer run by the governors of the three *doelens* but directly by town hall. Because the great hall of the Kloveniersdoelen was being used for purposes of all kinds, such as receptions and auctions, the city fathers thought it wise to remove some of the more vulnerably placed portraits. The *Night Watch* was therefore taken out of its paneling and moved up the Rokin to the town hall on Dam square (nowadays the Royal Palace). On the upper floor, it was installed in the Small War Council Chamber (figs. 47 and 48). Unfortunately, the space available for it, between two doors, was too small. In a move that was soon and forever after regretted, a blade was taken to the painting, and it was trimmed on all four sides, especially on the left.

In 1808, during a period when the Netherlands was ruled by France, Napoleon's brother Louis Napoleon was made king of Holland. He took the town hall of Amsterdam as his palace. The town government of Amsterdam moved out in haste, taking with them many art treasures, including the *Night Watch*, which they placed in a mansion on the Klove-niersburgwal known as the Trippenhuis, the Trip family mansion. A few months later, however, the king ordered its return. With the end of the Napoleonic wars and the establishment of the Kingdom of the

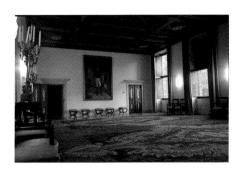

47
The room in the Royal Palace in Amsterdam in which the Small War Council Chamber was located when the building was still the town hall. The *Night Watch* is thought to have hung on the far wall, between the doors. However, no contemporaneous prints or drawings of the room during this period are known.

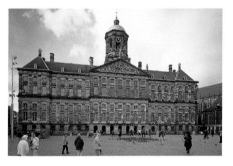

48
The Royal Palace in Amsterdam.

49>
In the new museum designed by Pierre Cuypers, the *Night Watch* was the center piece of the entire collection. Photograph of the gallery of honour of the Rijksmuseum from the main hall to the *Night Watch* room.

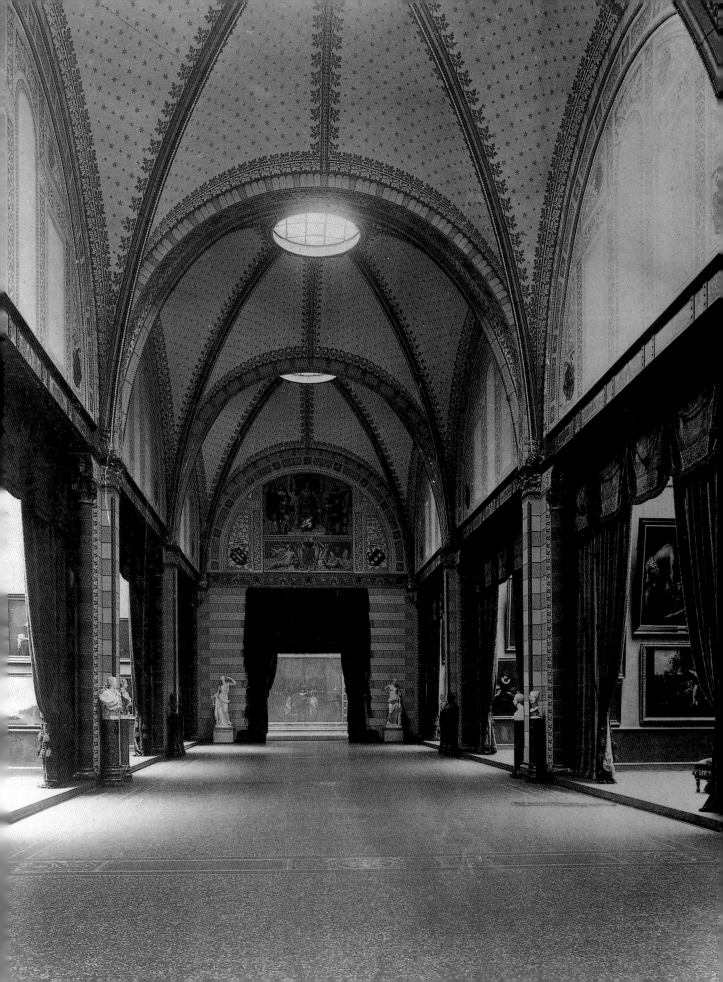

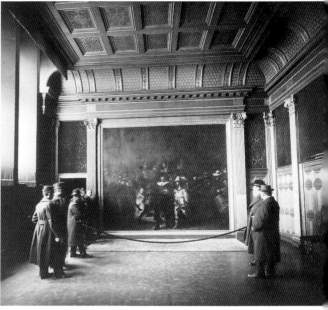

50

August Jernberg, *The Night Watch in the Trippenhuis,*
Amsterdam. A painting of 1880 after a sketch of 1872.
Malmö, Malmö Konstmuseum.

51

Following a controversy over the lighting of
the *Night Watch*, the painting was provided with
daylight from the side, which was thought to be
an improvement over lighting from the top.
Photograph taken in 1914.

Netherlands the painting was once more
taken to the Trippenhuis, as a loan from
the city of Amsterdam to the new Rijksmu-
seum (National Museum) that was housed
in the Trip family mansion (fig. 50).
The *Night Watch* remained in the Trippen-
huis until 1885, when it was moved to the
new Rijksmuseum building. If the move to
the town hall degraded and damaged the
painting, the placing of the *Night Watch* in
the Rijksmuseum entailed an unpreced-
ed glorification (fig. 49). The architect,
Pierre Cuypers, conceived of the national
museum as an encapsulation of all Dutch
history and art. The central object in his
vision was none other than the *Night Watch*.
He created a space for it where the painting
took on a nearly sacral character. The visi-
tor enters the main galleries through a hall
of honour resembling the nave of a Gothic
church. At the end of the nave, in a position

where in a church the altar would stand, he
hung the *Night Watch*. Admiration for the
Night Watch, which was already at a high
point, now turned into worship.
Since then the painting has left the Rijks-
museum only twice. In 1898 it was lent out
for a Rembrandt exhibition in the Stedelijk
Museum, in honour of the coronation of
Her Majesty Queen Wilhelmina. This was
the first museum exhibition in the Nether-
lands devoted to the work of an old master.
The next occasion was an unhappier one.
During the German occupation of the
Netherlands in the Second World War
(1940-1945), the authorities removed the
museum displays for safekeeping. The
Night Watch was taken to four different
locations before returning in 1945 to the
Rijksmuseum (fig. 53), where it has since
remained.

The hanging of the *Night Watch*, like the

cleaning of the painting, is a recurring
drama in its history. In fact, this has given
rise to more controversy over the years than
the cleanings. Both have their origins in
the same phenomenon, a certain discon-
tent with the visibility of the painting.
Critics were convinced that the lighting of
the painting with a skylight in the new
Rijksmuseum made it harder to see than
the side-lighting that had been used in the
Trippenhuis. They felt that the way it was
hung in the exhibition in the Stedelijk
Museum, lit from the side, was a great
improvement. This opinion was taken so
seriously that on April 24, 1901 the Dutch
government passed a law ordering an
investigation into alternative possibilities
for lighting the *Night Watch*. A committee
of twenty art historians, artists, restorers,
museum people, politicians and bureau-
crats brought out a report in May 1902.

Over the passionate protests of one of the members of the committee, who defended lighting from above, the report recommended side lighting. In order to do this, an extension had to be added to the *Night Watch* hall. Cuypers, who was on the committee, agreed to design a new Rembrandt room in back of the original one. In the new arrangement the *Night Watch* had to be hung at right angles to the back wall, so that it lost its privileged place as the focus of the hall of honor.

That solution did not satisfy the museum for long. In 1926 the *Night Watch* was moved back to its original hall, on a side wall with a mixture of daylight and artificial light - from above (fig. 51). An increased taste for authenticity led the Rijksmuseum in 1984 to move Rembrandt's masterpiece back to its original location, lit from above

with filtered daylight reinforced by artificial light. Throughout these maneuvers, the form, decoration and architectural detailing of the room in which the painting hung, which also influences its effect on the visitor, were also varied and changed numerous times. In the New Rijksmuseum currently being designed, the presentation of the *Night Watch* will undoubtedly be changed radically once more. However, since it is one of the aims of the renovation to return as much as feasible to Cuypers's concept, there is no reason to think that it will be moved away from its present, original location (fig. 54).

52

In the 1960s, the *Night Watch* was no longer in the axis of the Rijksmuseum, and was displayed against a white wall in the same way as all the other paintings in the museum. The painting was moved back to its central position in 1984.

53

The return of the *Night Watch* to the Rijksmuseum after the Second World War.

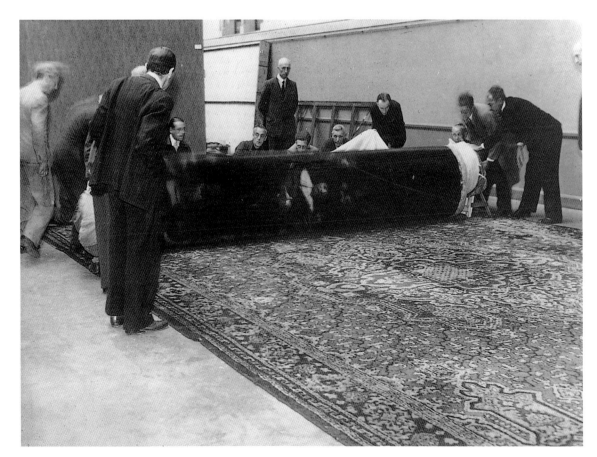

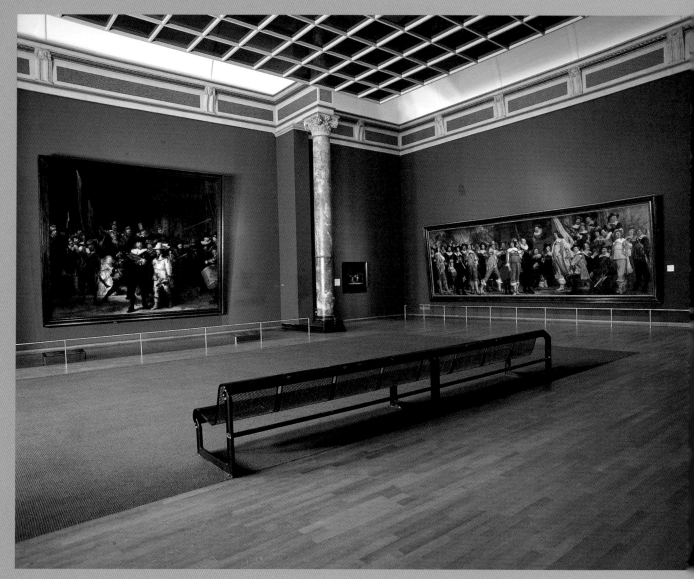

54

The *Night Watch* hall at the turn of the 21st century.
The frame dates from 1976 and was designed by Kees de
Bruyn Kops of the Rijksmuseum department of paintings.
After the major renovation of the entire museum now
being planned, which goes under the name The *New*
Rijksmuseum, the *Night Watch* and its hall will be brought
back closer to the atmosphere created for it by Cuypers.

Condition

Now light shines from the painting as it must have in Rembrandt's time. Now you see the men striding forth from a gate. The background, which used to be so puzzling, now reveals itself as a building. On the displayed shield you can now make out the letters that spell the names of the figures. And most important of all, even in the dark areas one sees the warm tones of the brown that modulates in many stages until it finally erupts in the golden yellow glow of the few main figures and the heads of the secondary figures.'

These words could have been written about the Night Watch at many times in the past. In 1976, when the painting was repaired and restored following an attack; in 1947, when after the war years it was cleaned and rehung; in 1906, when it was restored in honour of Rembrandt's 300th birthday; in 1851, on the occasion of extensive repairs; in 1771 and 1715, when we know the painting to have been cleaned. As it happens, they were written in 1889 by a certain L. Simons, in a notice in a Dutch newspaper on the opening of the Night Watch hall in the new Rijksmuseum building. Behind the excited tone we sense a certain dismay. All the wonderful features of the painting that are now going to be revealed, Simons implies, have been invisible or hard to see until that moment. The Night Watch as it was known until then was not true to Rembrandt's intentions. It is darker than the master intended. This effect is usually blamed on the varnish layer that is always applied to the surface of oil paintings like the Night Watch. When it is brushed on, the varnish is completely clear. However, as it hardens it becomes somewhat opaque and yellowish. When it is removed, the result is seen as a nearly miraculous revelation (fig. 55).

This recurring drama is part of the legend of the Night Watch. Like an ancient sun god, the picture goes through a periodic cycle of light and dark and light. The moment is often described as a reversal of the process of aging. 'The main thing,' wrote Simons, 'is the regeneration, the rebirth it has undergone...' In 1947, Willem Martin wrote in a book celebrating the cleaning of that year, that the Night Watch was 'rejuvenated.' Following the treatment of 1976, the Rijksmuseum told young readers of its *Kunst-Krant* that the painting was 'as good as new' (fig. 59). The excitement is understandable, but the terms used are misleading. Like everything else on earth, works of art are subject to the passage of time, and time moves only forward, not backward. The means used by restorers can be compared to medicine and cosmetics, which can help human beings prolong their lives and look better. But they do not turn back the clock,

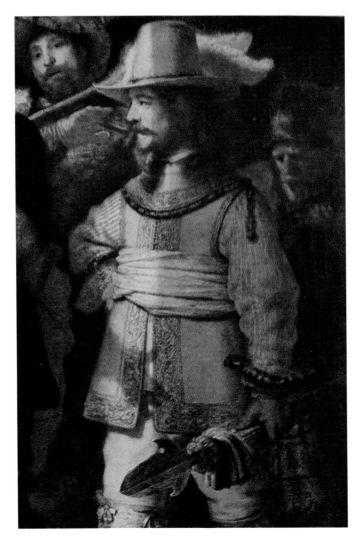

55
Photos such as this, taken during the restoration of the Night Watch in 1946-47, illustrate the dramatic effects that can be achieved by removing older layers of varnish.

and they almost always have undesirable side effects.

The *Night Watch* has suffered three main kinds of damage: physical mistreatment; the inevitable action of time; and the results of well-intentioned restorations.

Until it was moved into a proper museum in 1815, the *Night Watch* always hung in spaces that were used for all kinds of other purposes. It looked down on hundreds of meetings of military men and politicians, receptions, auctions and other events of the kind that take place in catering halls. In this situation, it is no surprise that it was damaged. Restorers have counted 63 different tears and holes in the canvas (figs. 56-57).

Beside those accidental damages, on more than one occasion a knife was taken to the painting on purpose. The earliest known event of this kind was the worst, and it was performed by the authorities in charge of it. In 1715 the *Night Watch* was removed from its original location to a room in another building where it was hung in a smaller space (see above, p. 34). To make it fit, a sizeable strip was cut off the left side, and smaller strips off the other three edges. Whatever qualities the *Night Watch* owed to its original dimensions and proportions were lost forever at that point.

In 1976 a mentally disturbed man slashed the *Night Watch* with a kitchen knife. As bad as the painting looked after the attack, not too much original material was lost. The incident and the restoration were a major media event. It was documented very well, and we can still follow the process step by step. The Rijksmuseum not only repaired the damage, but also cleaned and restored the *Night Watch* extensively.

Catastrophes aside, the *Night Watch* suffers damage day by day through the action of light, heat, air, moisture and friction of various kinds. These agents do not react with equal force on all parts of an old painting. Because some pigments change more than others, the passage of time affects the balance of colors within a painting. This has undoubtedly happened to the *Night Watch*.

Finally, there is a kind of damage that is the result of restoration. In 1975-1976, 1946-1947, 1851, and probably on one occasion in the more distant past, new lining canvases were attached to the back of the *Night Watch*. If this is not done, the original canvas to which Rembrandt applied his paints might sag and tear under its own weight, breaking the painted surface. To perform a relining, a painting has to be laid down on its face. The old lining is removed and a new one is glued to the back of the

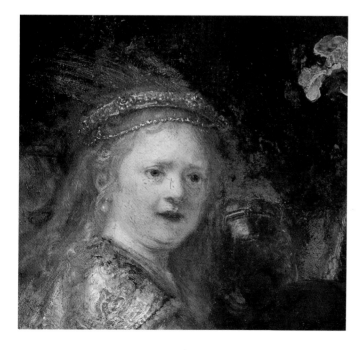

56

Stripped of varnish and repairs,

many areas of the *Night Watch* are revealed

to have disfiguring damage.

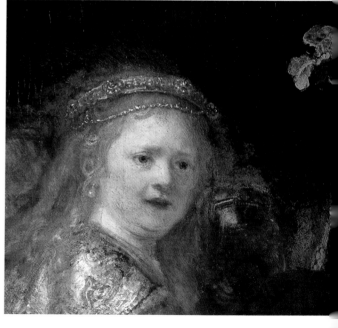

57

An expert conservator can do wonders in making

the painting look presentable.

original canvas. In order to make the lining canvas adhere properly, a certain pressure has to be exerted. This can flatten the painted surface and change the way it reflects light. The glue used in a relining creates other problems. In old relinings of the *Night Watch*, glue was pushed through the weave of Rembrandt's canvas and into the craquelure of the painted surface itself. The hardening of this glue may also contribute to the darkening of the *Night Watch*. In a technical term full of poetry, this phenomenon is referred to as blindness, as if the painting had eyes that had developed a cataract. In 1911, a bureaucrat wrote 'A painting treated with healthy varnish doesn't go blind every five or six years, as the *Night Watch* does.'

Other treatments applied in all good faith by the Rijksmuseum to the *Night Watch* are also suspected of having had a deleterious effect on it. From the 1880s until the Second World War, the museum regularly – one report says every two years – exposed the surface of the painting to alcohol vapors in order to make the varnish more supple and transparent. The museum also smeared the surface of the *Night Watch* with a South American medicinal substance knows as copaiva balsam, which made dull areas look brighter. The combination of these two methods, as has recent-

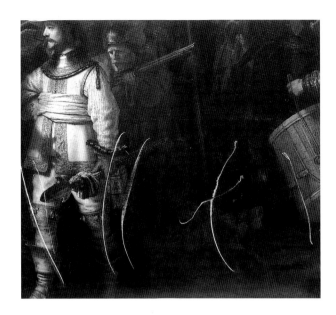

59

Detail of a damaged area of the *Night Watch* before repair.

ly been discovered, affects the way a painting reacts to the solvents used in regular cleanings. For nearly a hundred years, every cleaning of the *Night Watch* removed a microscopic bit of some of the original pigments. To what extent this has changed the appearance of the painting we do not know.

Accompanying the cyclical rising and setting of the sunlight in the *Night Watch*, a certain refrain can be heard from the restorers who bring about the periodic

brightening. When asked about the harm done by past restorations, they tend to say, 'Our predecessors worked conscientiously with the knowledge they had at the time. Unfortunately they were not aware of the dangers of ...' followed by a reference to copaiva balsam, alcohol vapor, certain kinds of glue, excessive pressure or another of the harmful substances or methods used in the past. 'Today we know so much more about the working methods of the old masters and the chemistry of painting that we are in a position to perform this work with absolute safety.' They too are being conscientious, but we do well to realize that no intervention, like no medicine, is without undesirable side effects.

For a telling comparison between a Rembrandt painting that has undergone little damage and the main detail of the *Night Watch*, see figs. 60 and 61.

Aside from the disfiguring losses, there is also a rather significant addition to the painting by another artist than Rembrandt. The shield that Simons referred to, hanging conspicuously in the upper right center, was added around the middle of the seventeenth century, sometime after 1649

41

58

Front page of *Rijksmuseum Kunst-Krant* (Art Newspaper), edition of March 1976: 'The Night Watch as good as new'. Amsterdam, Rijksmuseum.

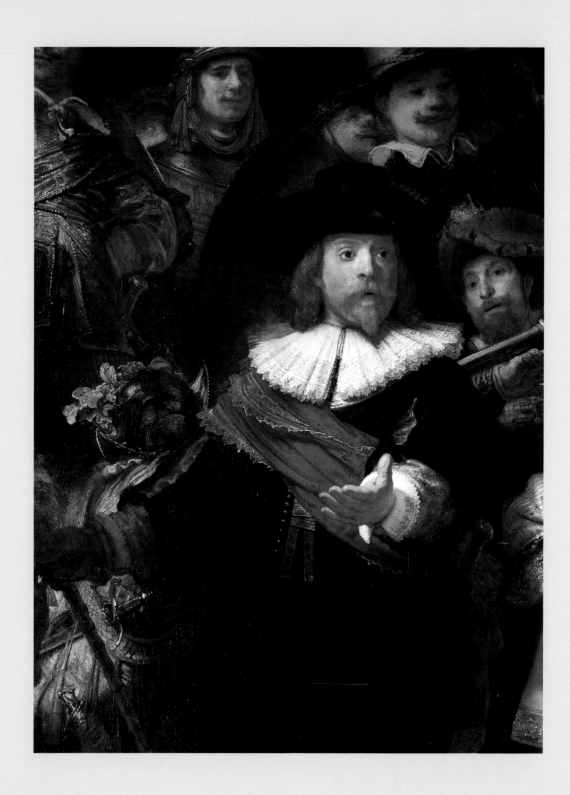

60

Frans Banning Cocq,

detail of the *Night Watch*.

Amsterdam, Rijksmuseum.

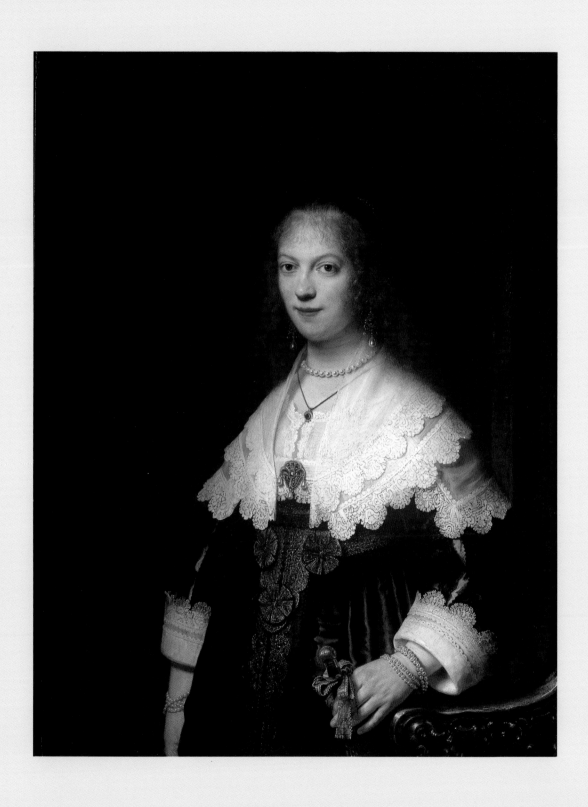

61

Rembrandt, *Maria Trip*, 1639.
Amsterdam, Rijksmuseum. Like the contemporaneous
Night Watch, this is one of the extremely few paintings

by Rembrandt that is still owned by the heirs of the
original patron. The surface of this portrait, which was
not subject to the same harsh treatment and repeated
restorations as the *Night Watch*, contains a wealth of

subtlety and refinement that once must have
characterized the portrait of Frans Banning Cocq
in that painting as well.

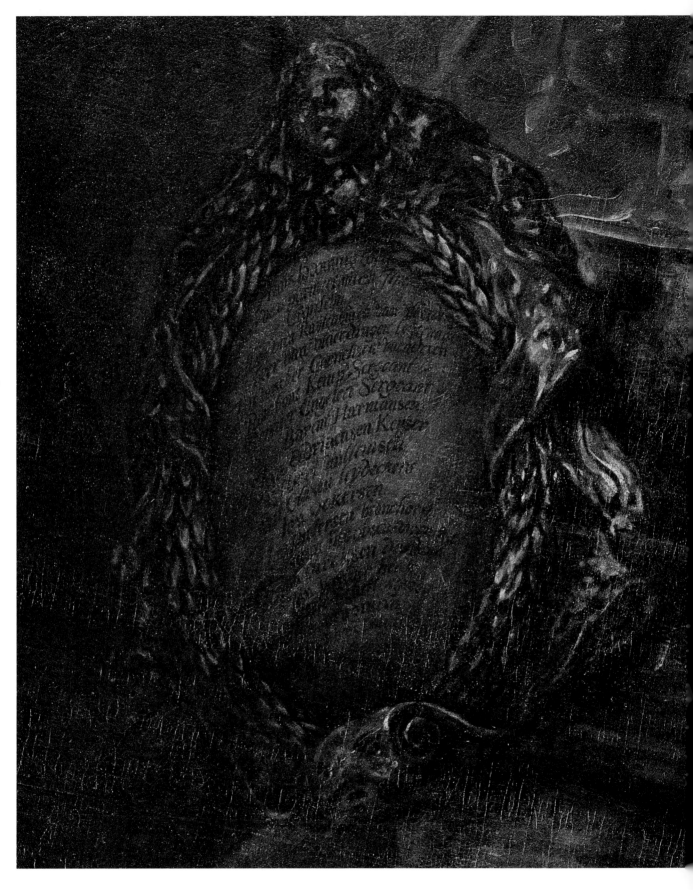

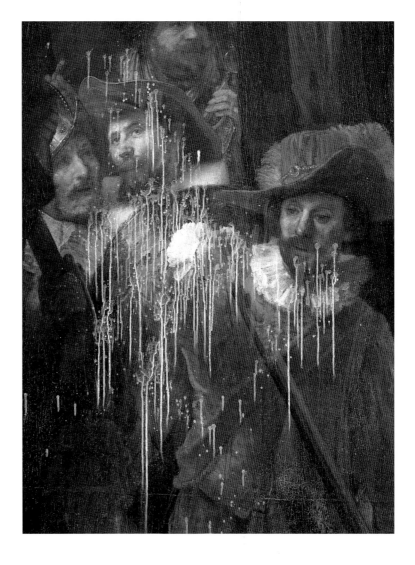

(fig. 62). Although it is interesting in itself and is not disturbing in the composition, it nonetheless creates a rather prominent center of visual and human interest in the *Night Watch* that was not put there by the master and was not part of his conception of the painting.

That is the bad news. The good news is that the *Night Watch* is still with us, and that the painted layer as we see it – despite those 63 holes, which are mostly small – has relatively little overpainting by later restorers. When standing in front of the *Night Watch* or studying it in a reproduction it is hard to discount all those effects: the

trimming of the canvas, the darkening, the damages, the flattening of the paint, the worn-down surface and the overpainting. A great help in imagining what the *Night Watch* looked like originally is a small copy after it, probably made by the Dutch painter Gerrit Lundens within ten years after the *Night Watch* was completed (fig. 36).

To answer the question we posed above – 'Is it still the painting Rembrandt left us?' – we can say, with a bit of hesitation and clearing of the throat, 'Well, basically it is.'

<62

Detail of the *Night Watch*, with the medallion showing the names of the officers and guardsmen. Amsterdam, Rijksmuseum.

According to S.A.C. Dudok van Heel the names of the guardsmen are in order of their seniority in the company. The medallion was added around 1650 by another artist. Could it have been a response to criticism, first expressed in print in 1678, that the individual figures did not come out strongly enough?

63>

Like many other famous cultural artefacts, the *Night Watch* attracts its share of unwanted as well as wanted attention. When a mentally disturbed man attacked the painting with acid in 1990, the museum was prepared. A guard was able to throw water onto the affected spot from a bucket placed nearby for this purpose. The damage was thereby limited to the varnish layer, which was easily repaired.

What people have thought of it

From the moment it was hung in the Kloveniersdoelen, the *Night Watch* was a famous painting. From the start it was Rembrandt's most famous painting, and over the years it has become the most famous painting in the Rijksmuseum, the most famous painting in Holland, one of the most famous paintings in the world. It rivals in fame Leonardo da Vinci's *Mona Lisa* and *Last Supper* (which Rembrandt copied in a drawing) and the *Potato eaters* and *Sunflowers* of van Gogh (who loved Rembrandt.) Numerous books have been written on it alone. Needless to say, in the course of time opinions of all kinds have been vented about it. Needless also to say

that the *Night Watch* is such an icon that you cannot easily look at it or read about it with an open mind.

Remarkably, the most frequently heard judgments, both positive and critical, found expression in the very first recorded reaction to the *Night Watch*. It is a brilliant passage in a treatise on painting by Samuel van Hoogstraten, published in 1678. What makes the passage all the more important is that van Hoogstraten was a pupil of Rembrandt's at the very time that the *Night Watch* was painted and delivered. What he writes about the *Night Watch* sounds like the kind of thing that would have been said about it when it was first hung.

His book is called *Inleyding tot de Hooge Schoole der Schilderkonst* (Introduction to the Academy of Painting, or to Advanced Painting). In it van Hoogstraten praises the *Night Watch* as a prime example of a painting that successfully combines observation from nature with pure artistic invention. The individual motifs in a painting, he wrote, are 'imitations' of real things. But combining them into a composition is an intellectual achievement that exists only in the artist's mind. 'It is not enough that a painter place his figures in rows one beside the other. You see far too much of that here in Holland in the *doelens* of the civic guard. True masters manage to give unity to the

46

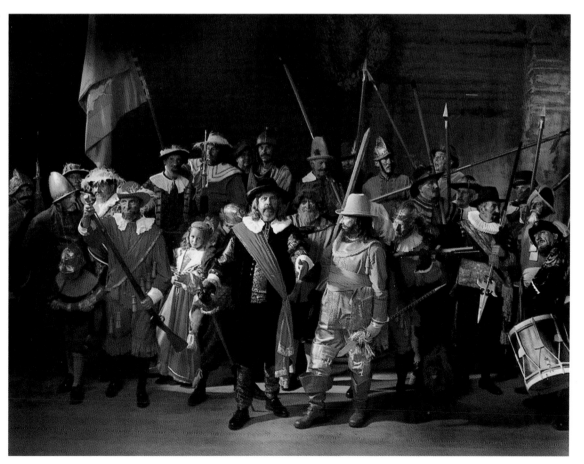

64
Although they are no longer militia bodies, shooting companies exist in the Netherlands to our day. One such group, the shooting company Berg en Terblijt, has adopted the *Night Watch* as a living emblem. They pose in the costumes and positions of the sitters to recreate the painting as a tableau vivant.

47

tire work.... Rembrandt achieved this in
is painting in the *doelen* in Amsterdam
tremely well. According to some too well,
y making more of the big picture in his
magination than of the individual por-
aits that were ordered from him. Howev-
, I feel that this same work, open to criti-
sm though it may be, will surpass all its
mpetitors. It is so picturesque in concep-
on, so graceful in the placing of the fig-
es and so powerful that beside it, in the
dgment of some, all the other paintings
the Kloveniersdoelen look like playing
rds. Although I do wish that he had lit it
ith more light.' The verb he uses in the
st sentence literally means to set a fire.
his too may have contributed to the rise
the notion that the painting is a night
ene illuminated by torchlight.

This passage contains the germ of one
the most persistent myths in the history
art: that the sitters to the *Night Watch*
ected the painting. Van Hoogstraten
plies that there was a certain measure of
scontent concerning the individual por-

traits. Still, there is no evidence that the sit-
ters complained, as some other sitters did
complain to Rembrandt about their por-
traits. In all, the myth should probably be
seen as an example of psychological projec-
tion. The people who made it up were
themselves disappointed by the portraits.
Rather than saying this, they attributed
the discontent to the sitters.

Van Hoogstraten's prediction that the
Night Watch would surpass all its competi-
tors in the eyes of later judges has held true
in general. But not always. Its chief com-
petitor among the other group portraits in
the Kloveniersdoelen is the *Company of Cap-
tain Roelof Bicker* by Bartholomeus van der
Helst. Especially in the eighteenth century,
when they both hung in the Small War
Council Chamber of the Amsterdam town
hall, van der Helst's painting seems to have
been preferred. It was not only tourists who
expressed this opinion but even major
artists. Sir Joshua Reynolds, artist, academi-
cian, teacher, author of treatises on art –
and an avid collector of Rembrandt draw-

ings – was so disappointed in the *Night
Watch* that he even went so far as to doubt
that Rembrandt painted it.

There are no better closing words than
what Vincent van Gogh wrote to his broth-
er Theo on 10 or 11 October 1885, after
spending three days in the Rijksmuseum.
'Rembrandt penetrates so deeply into mys-
teries that he says things for which there
are no words in any language. People are
right to call him a magician – that's not an
easy job.'

Lambertus Claessens, *Etching of* The Night Watch, *first state*.
Amsterdam, Rijksmuseum. The numbers and the key were added
by Egbert Haverkamp Begemann, in his book of 1982 on the
Night Watch. Some of the identifications in his legend have been
changed. The information about the sitters is also from that
invaluable source.

48

The two officers, three sub-officers and thirteen guardsmen
of the Amsterdam Musketeers' company from the second
precinct that Rembrandt painted for the great hall of the
Kloveniersdoelen, together with sixteen auxiliary figures
who did not pay to be included in the painting. Only a few
of the known sitters can be identified with figures in the
painting. Figures 21, 26 and 34 were not yet inserted in this
state of the print.

1. Frans Banning Cocq (1605-1655), lord of Purmerland and
Ilpendam, captain. Son of a wealthy druggist, son-in-law of
a far wealthier city father of Amsterdam from whom he
acquired his title. He followed a career in town government,
eventually becoming burgomaster in 1650 for the first of
four terms.
2. Willem van Ruytenburch (1600-1652), lord of Vlaardingen,
lieutenant. Son of a merchant in spices who bought an
aristocratic title that he passed to his son. He followed a
lesser career in Amsterdam politics.
3. Jan Cornelisz. Visscher (1610-1650), standard-bearer.
Used the inheritance from his family fortune to collect art
and books, and practiced music.
4. Reijer Engelen (1588-1651), sergeant, cloth merchant.
5. Rombout Kemp (1597-1654), sergeant. Succesful cloth
merchant, deacon of the Reformed Church, governor
of one of the city poorhouses.
6. Musketeer
7. Helmeted man with sword
8. Man with shield and sword (Herman Wormskerck).
Wormskerck was a wealthy cloth merchant.
9. Musketeer with furket and slow-match
10. Musketeer loading his weapon

11. Powder boy
12. Girl in gold and blue
13. Girl in gold and blue
14. Shooting youth
15. Head of a man
16. Head of a man
17. Head of a man
18. Helmeted man with shield and sword
19. Head of a man
20. Pikeman
21. Head of a man
22. Man supporting musket shot
23. Pikeman
24. Musketeer blowing the pan clean of unexploded
powder
25. Pikeman (Jacob de Roy?)
26. Head of a pikeman
27. Musketeer
28. Head of a man
29. Pikeman
30. Drummer (probably Jacob Jorisz.)
31. Head of a man
32. Bareheaded musketeer (in section removed ca. 1715)
33. Man with a hat (in section removed ca. 1715)
34. Child (in section removed ca. 1715)

Beside Engelen, Kemp and Wormskerck, four other
guardsmen in the *Night Watch* were also cloth merchants.
Others dealt in hemp, wine, spices and other trades.
Jan Keijser, a wine dealer, later became the tavernkeeper
of the Handbowmen *doelen*.